OXFORD
THEN & NOW
IN COLOUR

MALCOLM GRAHAM & LAURENCE WATERS

The History Press

First published in 2011

The History Press
The Mill, Brimscombe Port
Stroud, Gloucestershire, GL5 2QG
www.thehistorypress.co.uk

ISBN 978 0 7524 6340 7

Typesetting and origination by The History Press
Production managed by Jellyfish Print Solutions and manufactured in India

CONTENTS

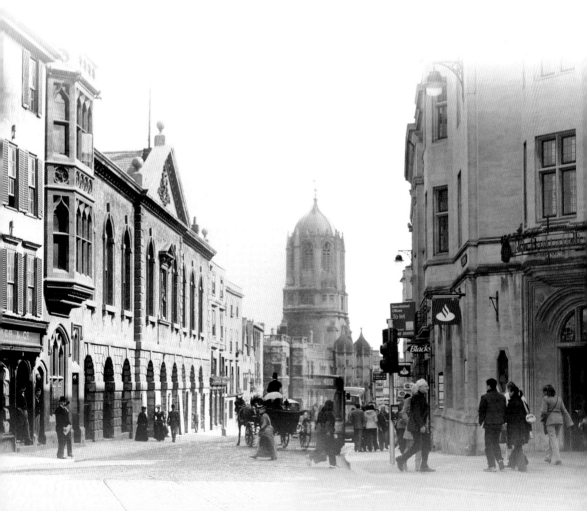

ACKNOWLEDGEMENTS

All the historical photographs are reproduced by kind permission of Oxfordshire History Centre, Oxfordshire County Council.

ABOUT THE AUTHORS

Malcolm Graham was Oxford City's first full-time local history librarian before becoming local studies librarian for Oxfordshire County Council. He was then appointed head of Oxfordshire Studies, managing a busy major resource for local and family history until he retired in 2008. A keen local historian, Malcolm has published extensively on local history and given hundreds of talks and broadcasts over the years. He is also the biographer of Henry Taunt, whose photographs appear in this book.

A retired professional photographer and photography teacher, Laurence Waters has written or contributed as co-author to twenty-seven books on local history subjects. His main interest is the Great Western Railway, and he has written a great many books on the subject. Laurence is the honorary photographic archivist for the Great Western Trust at Didcot Railway Centre.

INTRODUCTION

A century ago, when Henry Taunt (1842–1922), the well-known local photographer, was taking the old photographs which feature in this book, Oxford was a comparatively small city with a population of 53,000; now, the city is home to around 150,000 people. Oxford then was still a market town and its prosperity largely depended on providing goods and services to the university, the suburbs and the surrounding countryside. The city seemed destined never to have a major industry and, if it was untrue that the city's only manufactures were parsons and sausages, its major employers were Oxford University Press, the railways, the building trade and local breweries; in addition both men and women were also employed in college service. Irregular employment caused financial problems, particularly during the university's long vacation when college servants were out of work, trade was slack and, according to tradition, grass grew in the High Street. All this changed within a generation as the enterprise of one man, William Morris, later Lord Nuffield (1877–1963), created a major motor industry at Cowley, bringing full employment to Oxford and district and attracting thousands of migrants from further afield. Oxford expanded greatly, particularly to the east and south-east, and several former villages are now included within the city boundary.

This book concentrates on the old city, which has famously been described as the Latin Quarter of Cowley. The area covered extends from the railway station in the west to Magdalen Bridge in the east and from St Giles' in the north to Folly Bridge in the south. The images are arranged in two sections, the first covering the western portion of the city centre and the second exploring the heart of the university between Carfax and Magdalen Bridge. The photographs taken by Laurence Waters in March 2011 show how much and, in some cases, how little, central Oxford has changed in the past century. Major historic buildings have generally been preserved, not least because Oxford was spared wartime bombing, and restoration since the 1950s has left many of them looking as good as new. University and college expansion has led to many significant new buildings and, since the 1960s, these developments have often retained the façades of older town houses which were previously seen as expendable. Commercial development, extending the central shopping area and providing larger premises for chain stores, has affected the area west of Carfax; here too, there was extensive slum clearance and whole communities were removed to suburban estates before city-centre living became fashionable. Some historic streets were widened to cope with the rising tide of traffic but gargantuan schemes such as the Christ Church Meadow Road were ultimately defeated. Since 1973, traffic has been restricted in the city centre and, in 1999, buses were removed from Cornmarket Street and High Street was closed to most vehicles during the day, except buses and taxis. Although these changes are still controversial, they have undoubtedly improved the experience of visiting Oxford, one of the world's great cities.

CARFAX

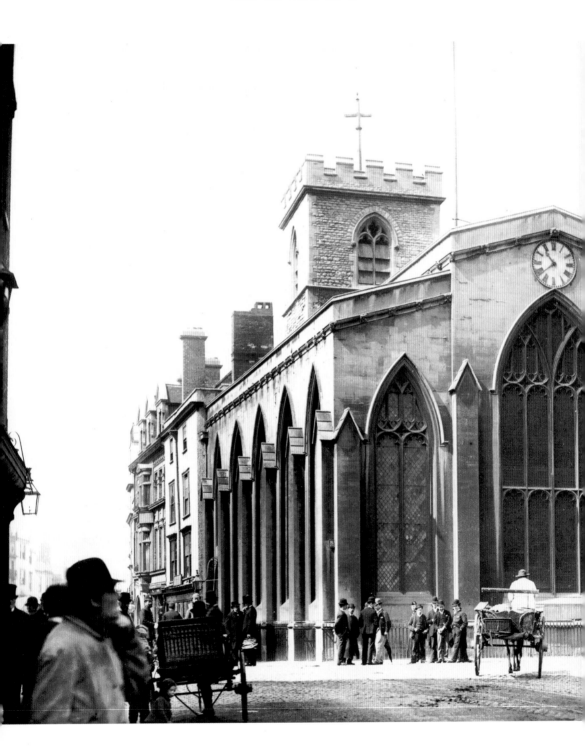

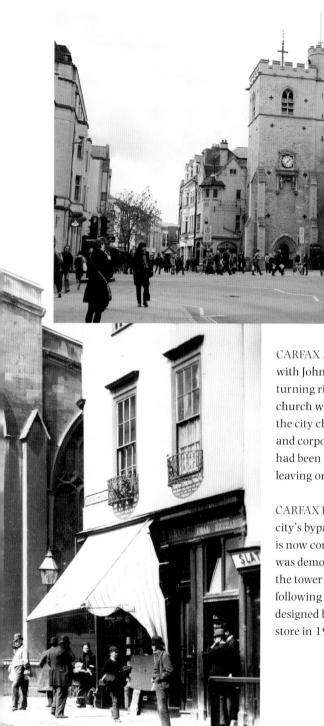

CARFAX AND ST MARTIN'S church in 1890 (left) with John Harris, the Horspath village carrier turning right into Cornmarket Street. St Martin's church was first recorded in 1004 and it became the city church, attended regularly by the mayor and corporation. The medieval and later structure had been demolished and rebuilt in 1819–21, leaving only the fourteenth-century tower.

CARFAX BECAME A busy crossroads until the city's bypass was completed in the 1960s but it is now comparatively quiet. St Martin's church was demolished in 1896 to widen the road and the tower was converted into a clock-tower the following year. The HSBC bank to the right was designed by Henry Hare and originally built as a store in 1900.

CORNMARKET STREET SOUTH

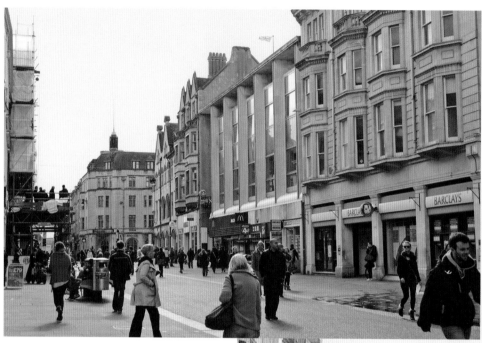

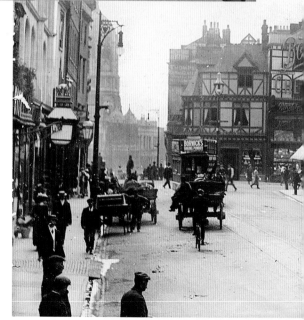

CORNMARKET STREET, LOOKING south towards Carfax in 1907 (right). Victorian commercial developments, most notably the three-gabled façade of Grimbly Hughes' high-class grocery store (1864), dwarfed the seventeenth-century timber-framed building housing Twining's grocery shop. Boffin's half-timbered restaurant at Carfax closes the view, with Boots the chemist next door representing the arrival of national chain stores.

PEDESTRIANS HAVE ENJOYED the freedom of Cornmarket Street since buses were removed in 1999. Barclays Bank expanded across the site of Twining's old premises in 1923 and in 1961 Littlewoods replaced

Grimbly Hughes' store with an uncompromisingly modern building which is now a McDonald's restaurant. At Carfax, Marygold House replaced Boffin's in 1930–1 as part of the contemporary redevelopment of the area.

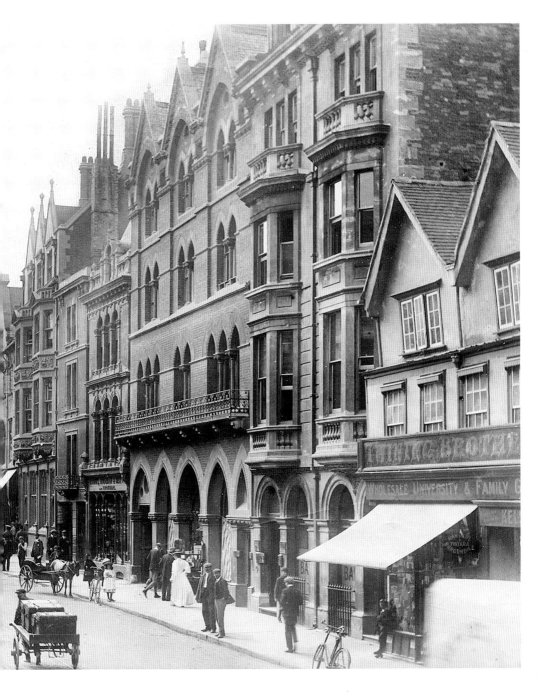

ST MICHAEL AT THE NORTHGATE CHURCH

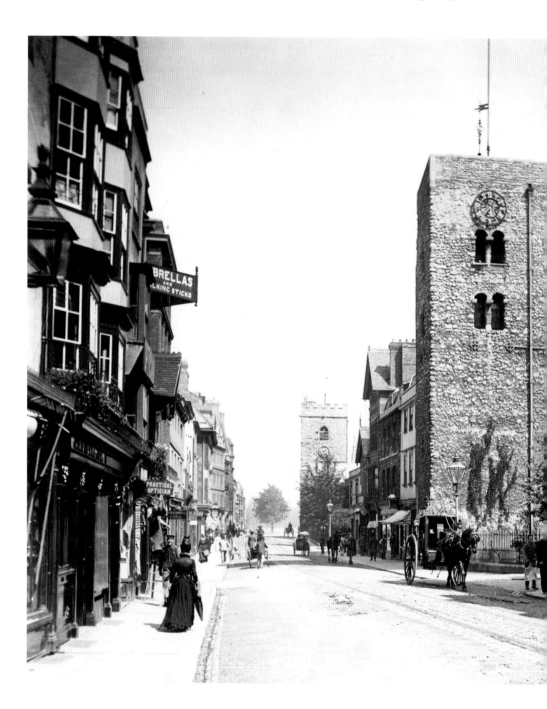

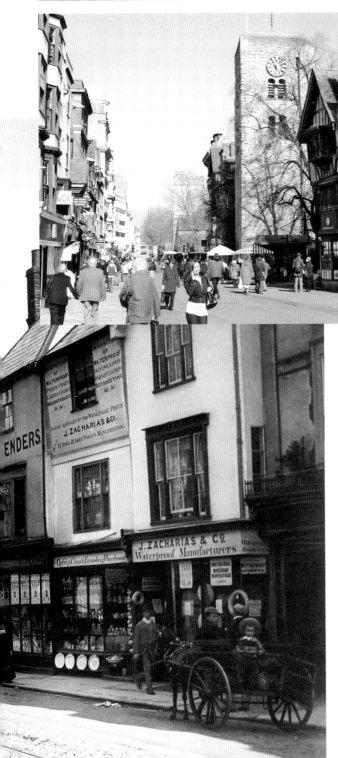

CORNMARKET STREET IN 1885 (left), looking north towards the Anglo-Saxon tower of St Michael at the Northgate church. Zacharias & Co., an outdoor clothing business best known for its 'wet-off' coats, occupied part of a former fourteenth-century inn opposite, with Harvey's the Tea Blenders on the corner of Ship Street. Tramlines had been laid in the centre of the street when horse-drawn trams were introduced to Oxford in 1881.

HISTORIC CORNMARKET IS still evident at this end of the street. A tree partially obscures the church tower but Zacharias's shop was carefully reconstructed after the closure of that old Oxford business in 1983. On the left-hand side of the street, tall bay-windowed frontages dating from the late eighteenth century mask older timber-framed buildings.

11

CORNMARKET STREET NORTH

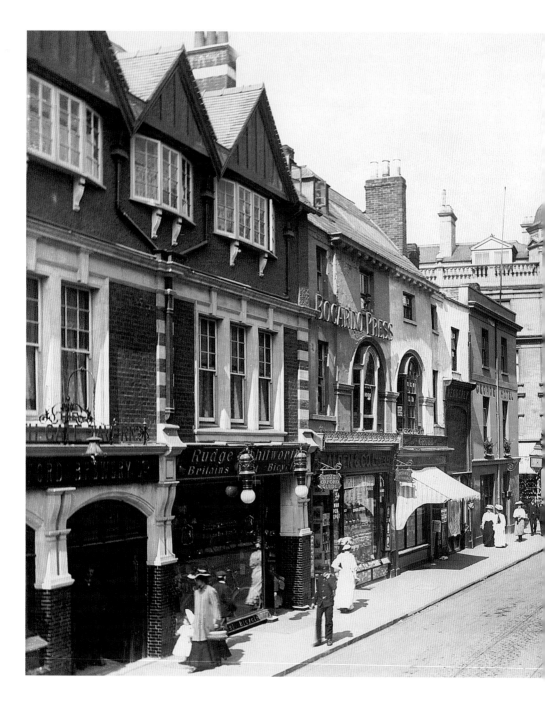

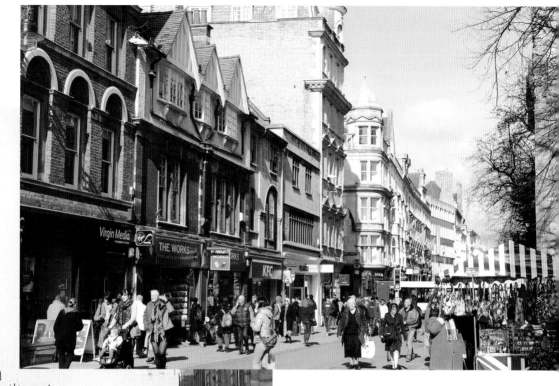

LOOKING INTO MAGDALEN Street from Cornmarket Street, 1907 (left). This is a deceptively quiet scene, showing uncrowded pavements and a single horse-drawn carriage waiting at the roadside. The contemporary rapid expansion of Elliston & Cavell's department store beyond George Street told a more prosperous story and the Northgate Tavern, nearest the camera, had been another recent development, built in 1879.

THE NORTHGATE TAVERN building survived the closure of the pub in 1971 and Debenhams retained the old Victorian and Edwardian frontages of Elliston's in a huge redevelopment scheme between 1999 and 2000. The former George Hotel, now a branch of the NatWest bank, on the corner of George Street, was described as 'Oxford's first skyscraper' when it was built in 1912.

NEW THEATRE

DEMOLITION OF OLD properties on the corner of George Street and Victoria Place, 1886 (right). George Street was outside the city wall and house building here was at its height in the seventeenth century. The raised footway at this point was formed in 1667 and the buildings behind it must have been erected soon afterwards.

OXFORD'S FIRST NEW Theatre was built here in 1886 when the university relaxed a ban on the staging of plays during term time! A second New Theatre was needed after

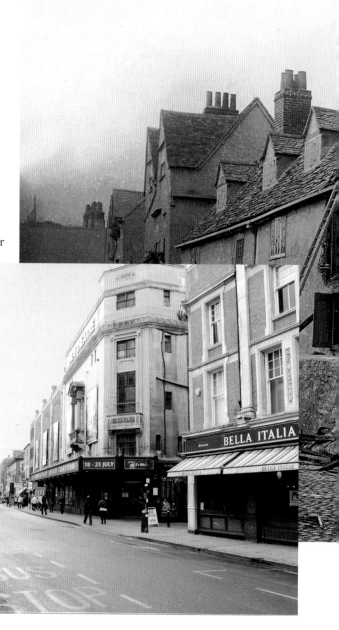

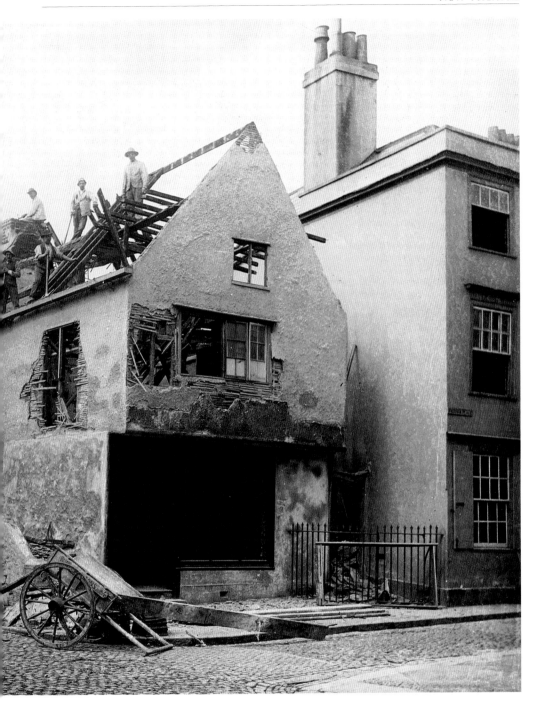

a fire in 1908 and the present building, designed by W. & F. R. Milburn, is the third one, erected in 1933–4. The city's largest theatre, accommodating over 1,800 people, it was known as the Apollo between 1981 and 2003 but it is now the New Theatre again.

ST GILES'

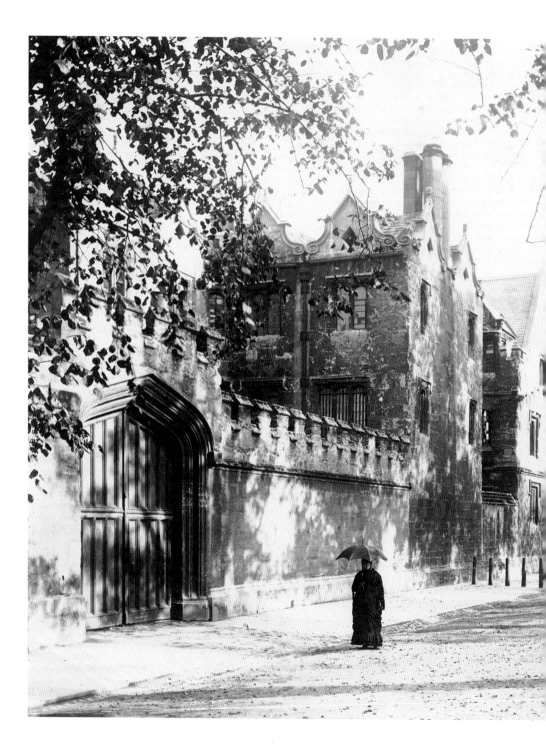

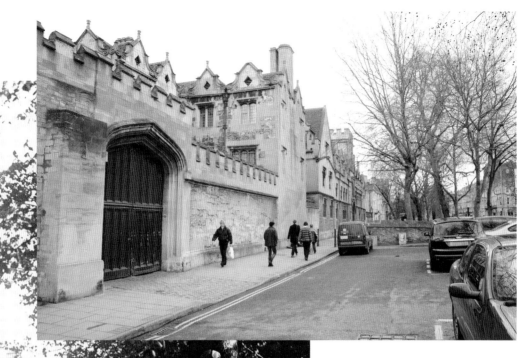

A WOMAN WITH a parasol outside the St Giles' frontage of St John's College in 1880 (left). Sir Thomas White had founded St John's in 1555 and the new college took over the fifteenth- and sixteenth-century buildings of the dissolved monastic foundation, St Bernard's College. This view shows the gabled Cook's Buildings of 1642–3 and an early seventeenth-century addition to the north of those original buildings.

WITH RENEWED OR cleaned stonework, St John's College now presents a much crisper elevation to St Giles'. Parked cars occupy much of the foreground but trees still flourish in the walled enclosure in front of the college.

ST JOHN'S COLLEGE

THE FRONT QUAD at St John's College in 1870. St John's inherited the quad from St Bernard's College and the north range contains the hall and college chapel. Battlements were added to the buildings in 1617 and sash windows replaced older windows around much of the quad in the eighteenth century.

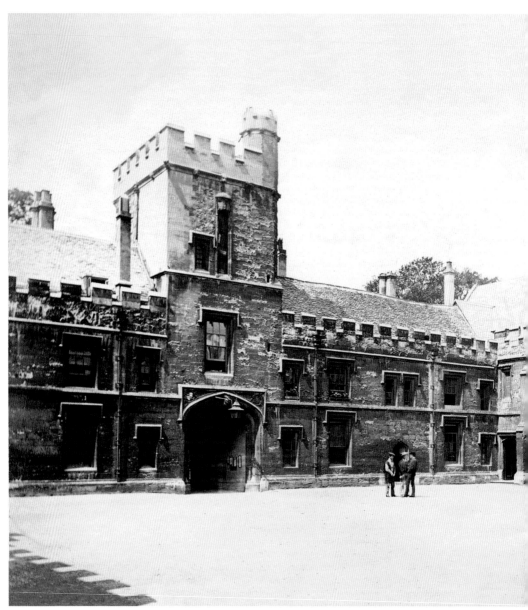

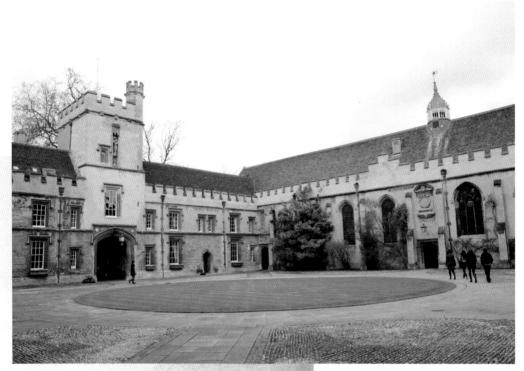

THE REPLACEMENT OF decayed Headington stone has restored the architectural details of the front quad, and the chimneys have vanished. A clock was added as a war memorial above the passage between hall and chapel in 1919. Luxuriant growth masks the hall window and the gravel quad is now paved and laid to lawn.

BEAUMONT STREET

BEAUMONT STREET, LOOKING west towards Worcester College in 1919 (left). St John's College had Beaumont Street laid out in 1822 as part of a plan to develop college land north of Gloucester Green. Three-storey terraced houses fronted with ashlar stone filled the street within a decade, bringing a touch of Bath or Cheltenham into Oxford. The Ashmolean Museum, partly visible on the right, was added in 1841.

IN SMOKE-FREE modern Oxford, Beaumont Street's stonework looks much cleaner but the road is now a busy thoroughfare. The extension west of the Ashmolean Museum was a sympathetic addition to the scene in 1939–41 and, on the left, a distant canopy marks the tasteful insertion of the Oxford Playhouse façade in 1938.

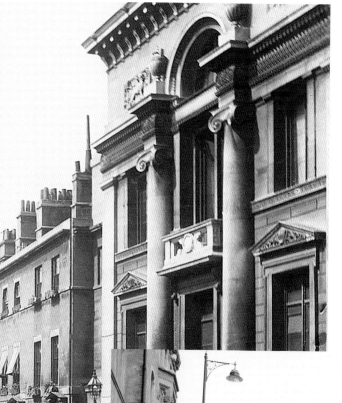

WORCESTER COLLEGE

THE MEDIEVAL SOUTH range of Worcester College, photographed in 1880 (below). These buildings date from the fifteenth century and were part of Gloucester College, founded in

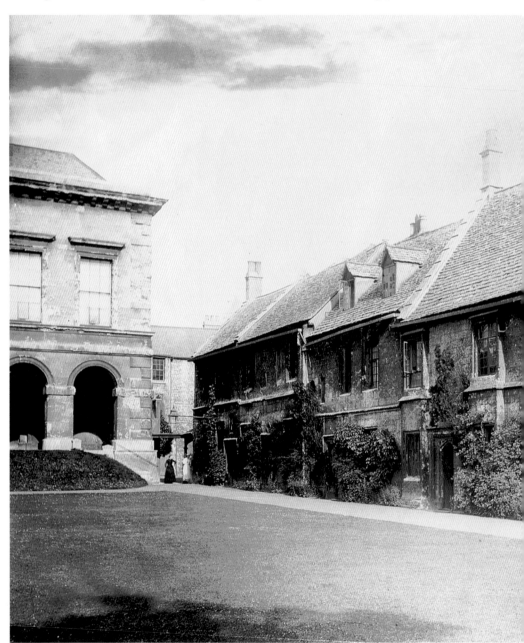

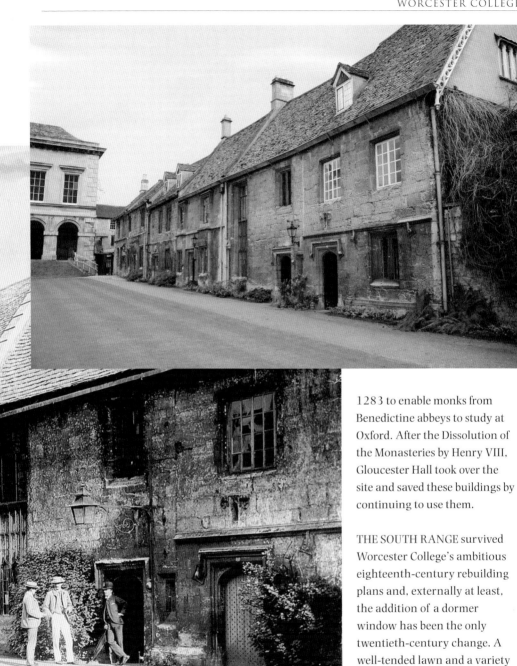

1283 to enable monks from Benedictine abbeys to study at Oxford. After the Dissolution of the Monasteries by Henry VIII, Gloucester Hall took over the site and saved these buildings by continuing to use them.

THE SOUTH RANGE survived Worcester College's ambitious eighteenth-century rebuilding plans and, externally at least, the addition of a dormer window has been the only twentieth-century change. A well-tended lawn and a variety of plants and climbers add to the building's picturesque character.

OXFORD CANAL

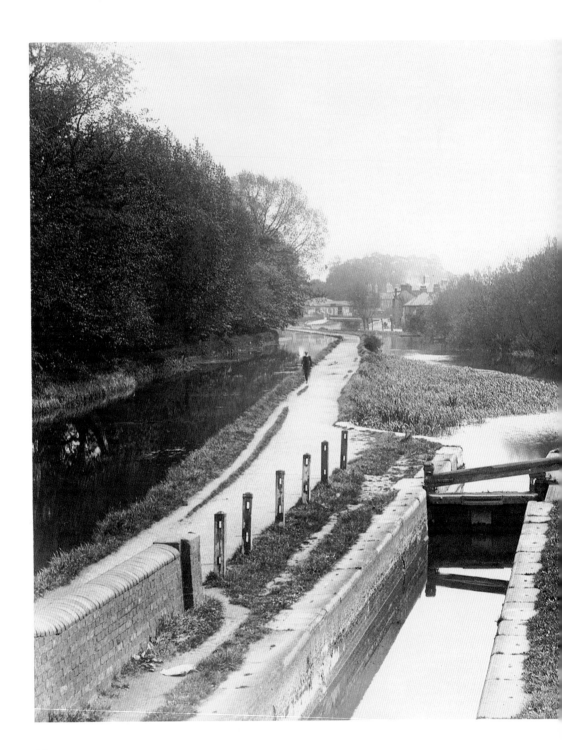

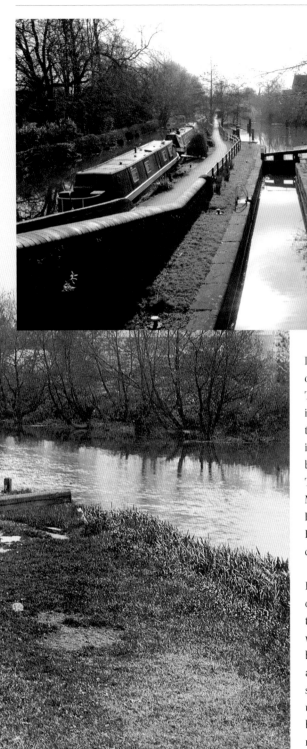

LOOKING INTO OXFORD from Isis or Louse Lock Canal in 1920 (left). The Oxford Canal opened to a basin in New Road on 1 January 1790 and the lock in the foreground was added in 1796 to provide an improved link between the canal and the main river Thames away to the right. The Castle Mill Stream flows on towards Hythe Bridge, past the site of the Cistercian Rewley Abbey which was largely a coal yard at this date.

ISIS LOCK TODAY (above) with trees obscuring distant views and the towpath a much narrower track for walkers and cyclists. Lord Nuffield bought the Oxford wharves in 1937 as the site for Nuffield College and the surviving stub of the canal is now used for residential moorings. Houses built on the coal yard site in the 1990s now rear above the trees to the right of the Castle Mill Stream.

RAILWAY STATION

OXFORD'S RAILWAY STATIONS during the floods of November 1875. The overall roof of the Great
Western Railway station (opened in 1852) is visible in the background, with part of the locomotive

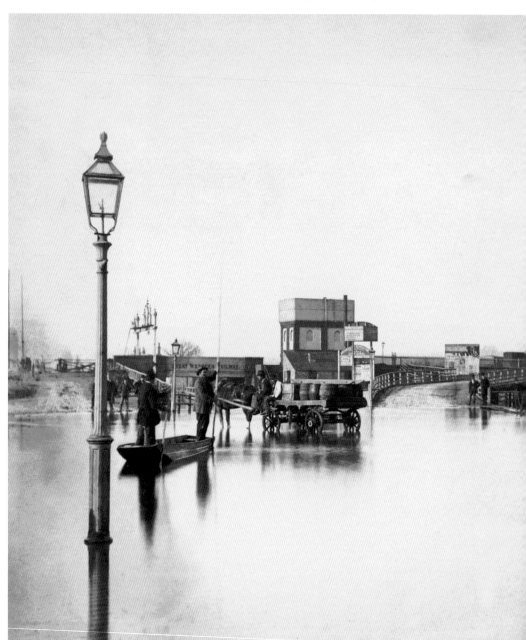

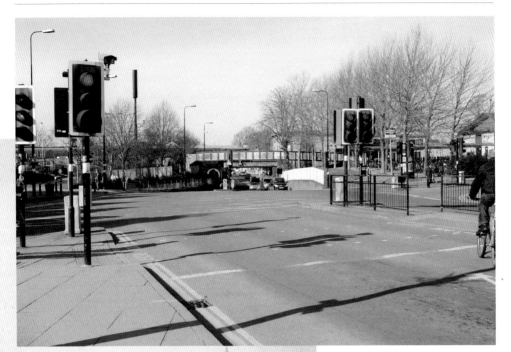

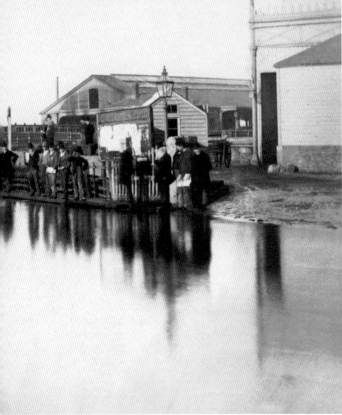

shed of the London & North Western Railway station away to the right. The foreground is occupied by a group of stranded passengers and two of the enterprising punt owners who ran an impromptu water-taxi service.

THIS PART OF Park End Street was redesigned as Frideswide Square in 1999–2000 during the building of the Saïd Business School and a profusion of traffic lights now controls this complicated junction. The original Great Western Railway station lost its overall roof in 1890–1 and the rest of the building was demolished in 1969–70. The present station, with a bus interchange and extensive cycle parking, dates from 1990.

LOWER FISHER ROW

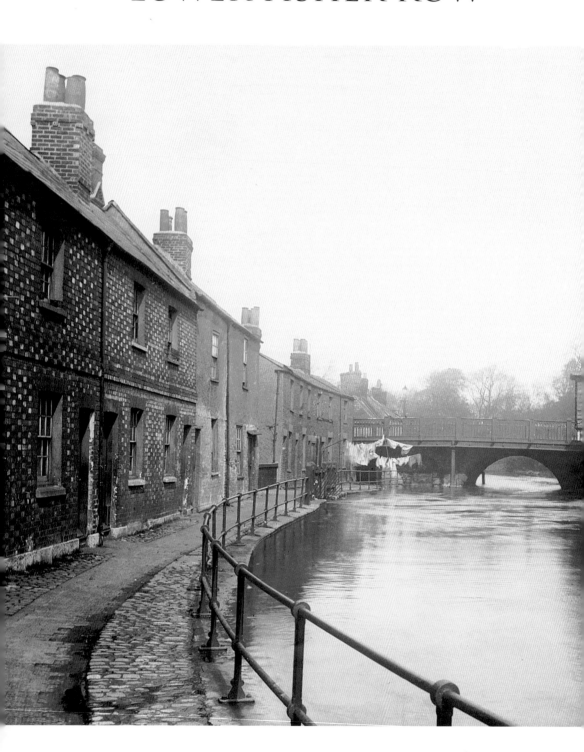

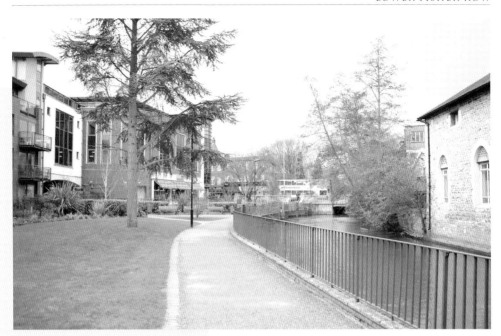

LOWER FISHER ROW, looking north towards
Pacey's Bridge in Park End Street, 1920 (left). Fisher
Row, home to generations of Oxford watermen
and fishermen, was built on the bank between two
branches of the river Thames, the Castle Mill Stream
(seen here) and the Wareham Stream behind these
houses. Park End Street was a new road and sliced
through the row in 1769–70.

PACEY'S BRIDGE WAS rebuilt in 1923 as part
of a scheme to improve the western exit from the
city. Flood-prone houses in Fisher Row were later
condemned and most were pulled down in 1954.
The site became a quiet public garden which was
replanned when The Stream Edge apartments on the
left were built in 2005.

OXFORD CASTLE

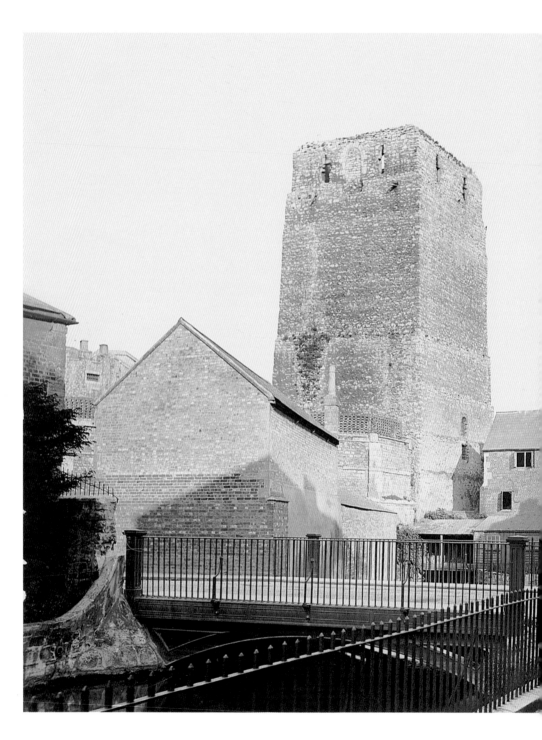

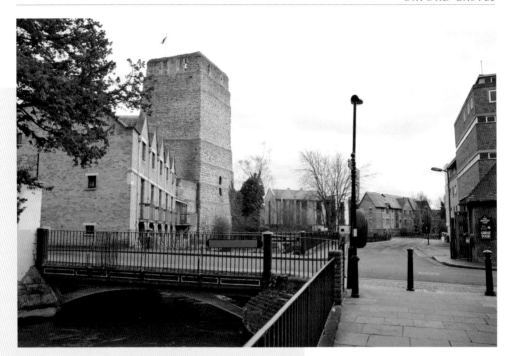

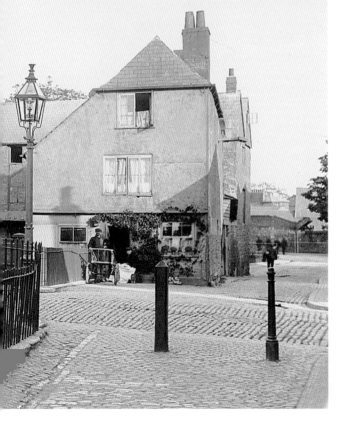

ST GEORGE'S TOWER from Quaking Bridge in 1901 (left). The tower is usually dated to around 1074, soon after the establishment of Oxford Castle in 1071 but it may have originated as a slightly earlier watch tower protecting the western entrance to the town. There was a Castle Mill at the foot of the tower by 1086 and the name Quaking Bridge, referring perhaps to a drawbridge, was first recorded in 1297.

THE CASTLE MILL was sadly demolished for road widening in 1930 but St George's Tower is now accessible to the public following the Oxford Castle development of 2004–6. Beyond the current Quaking Bridge, which dates from 1835, St George's Gate provided student housing for St Peter's College in 1995.

RIVER THAMES AT
FOLLY BRIDGE

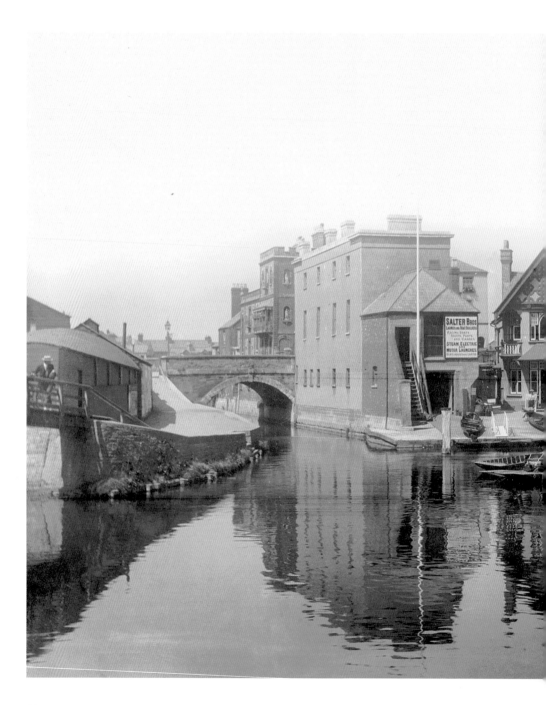

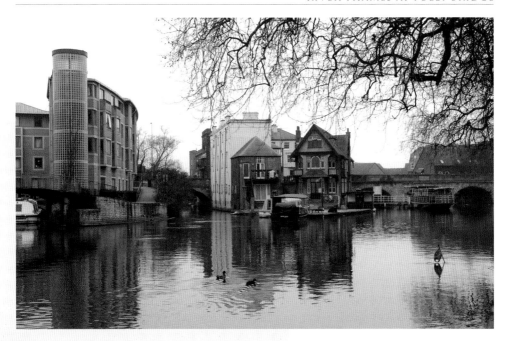

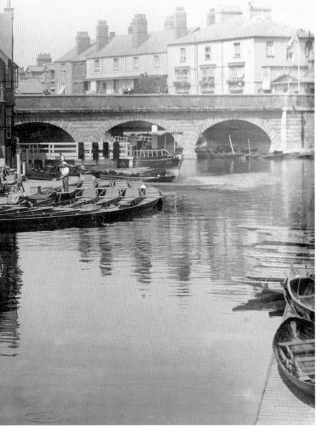

FOLLY BRIDGE FROM the east in 1911 (left). As rebuilt in the 1820s, Folly Bridge provided a basin for commercial river traffic beyond the three-arched bridge and the navigation continued through a lock and under the single arch to the left of the picture. The lock was removed in the 1880s and, by this date, Salter Brothers were running their boat-hiring business and river steamer service from the buildings in the foreground.

SALTER'S PREMISES ON Folly Bridge Island are little changed and the firm still hires out boats and takes passengers by steamer between Oxford and Abingdon on summer afternoons. The striking building on the left of the modern photograph is the Hertford College Graduate Centre, designed by Oxford Architects Partnership and completed in 2000.

ST ALDATE'S STREET, LOOKING NORTH

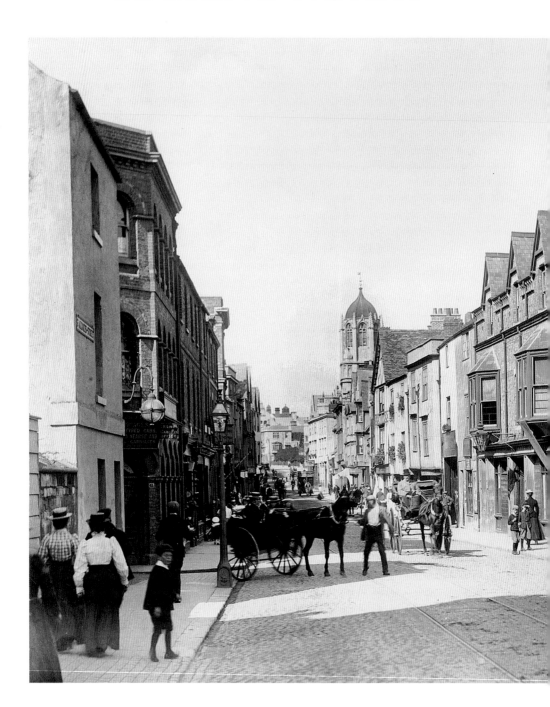

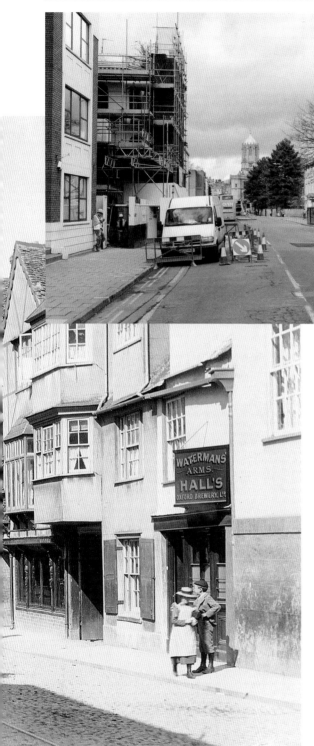

ST ALDATE'S IN 1900 (left), looking north towards Christ Church from the Waterman's Arms. Development had extended beyond the town walls and down St Aldate's in medieval times and by the seventeenth century, houses filled the street frontage and much of the land behind it. The brick-built Apollo pub on the left, near the man with a pony and trap, was an isolated piece of rebuilding in 1861 and the area remained seriously overcrowded.

ROAD WIDENING AND slum clearance devastated this part of St Aldate's but the former Apollo pub (currently being restored by the international college Bellerbys) and Tom Tower provide some continuity. The road was part of the main A34 until the 1960s but is now at times uncannily quiet. The stone-fronted police station beyond the trees on the right dates from 1938 and provides the base for Oxford's fictional detective, Inspector Morse.

ST EBBE'S CHURCH

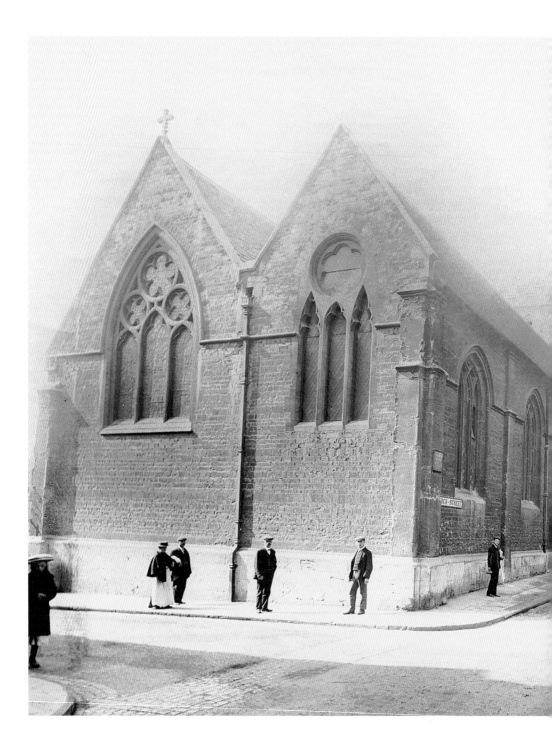

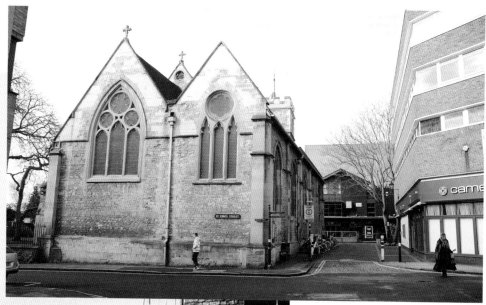

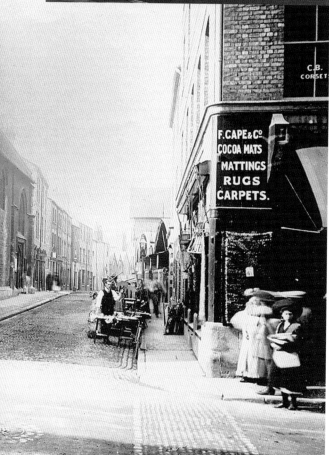

ST EBBE'S CHURCH and the entrance to Church Street, 1907 (left). The church, with a rare dedication to a seventh-century Northumbrian saint, was first recorded in 1005 but the growth of the parish in the 1810s made necessary this new building, which was designed by William Fisher and built in 1816. St Ebbe's Street became a bustling shopping centre and Cape's drapery business, just visible on the right, was one of its best-known features.

ST EBBE'S CHURCH is little changed but Cape's, the store where Oxonians felt they could buy almost anything, closed its doors for the last time on 13 January 1972. The Victorian premises were soon torn down and replaced by a smart new Fenwick's fashion store; the Camera nightclub is the most recent occupant of this building.

QUEEN STREET

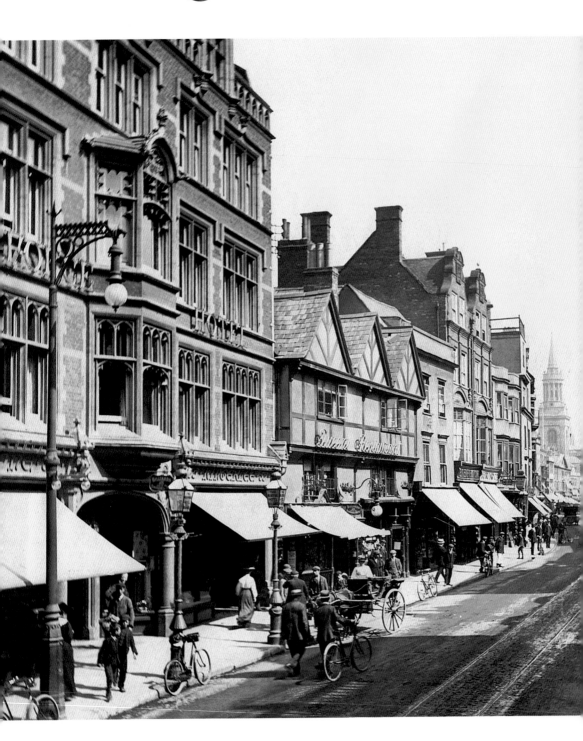

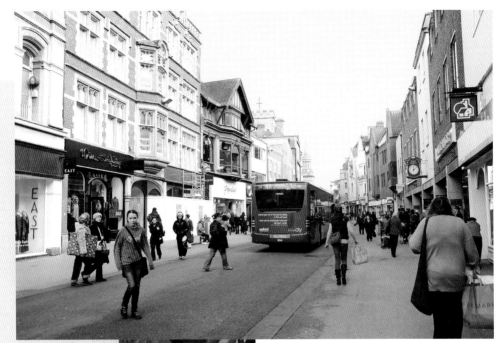

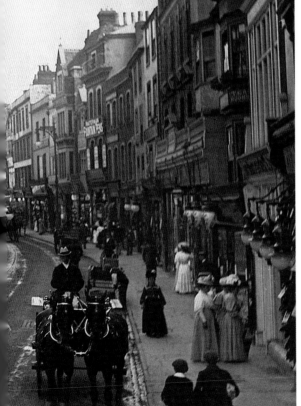

QUEEN STREET IN 1907, looking towards Carfax and the distant spire of All Saints' church (left). The three-gabled Queen's Restaurant, dating back to the seventeenth century, now looked almost out of place in a shopping street dominated by Victorian commercial buildings such as the Wilberforce Hotel (1888) on the left. Horse-drawn trams linked Oxford's suburbs with the city centre but this was a golden age for cycling shoppers.

QUEEN STREET WAS closed to most traffic as long ago as 1969 but pedestrians still have to beware of buses. Morris Garages replaced the Queen's Restaurant in 1912 with the gabled and half-timbered building, which provided car showrooms on two floors. The ornate clock on the right picks out Marks & Spencer's store, which opened here in 1978.

QUEEN STREET, LOOKING WEST

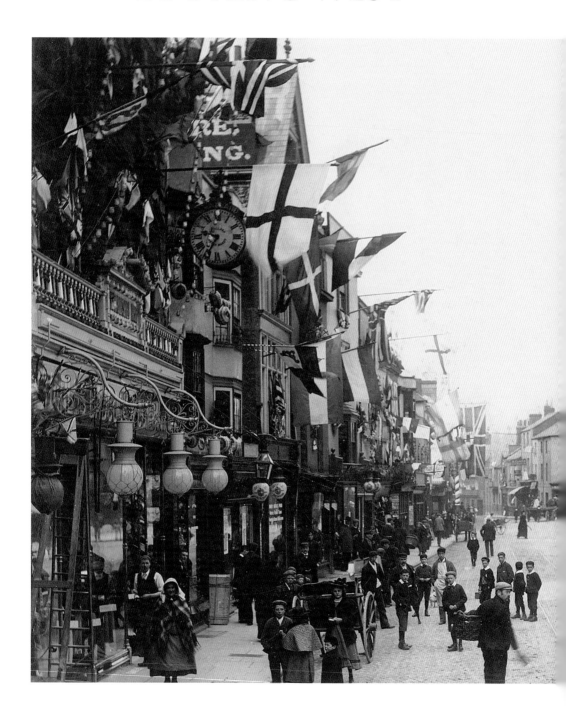

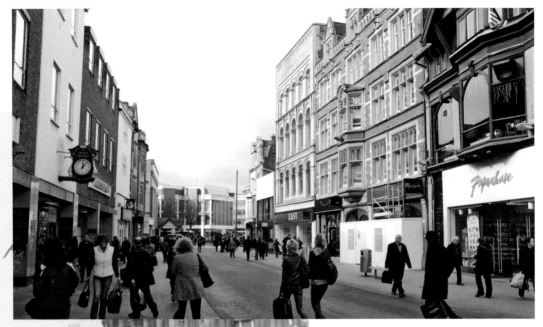

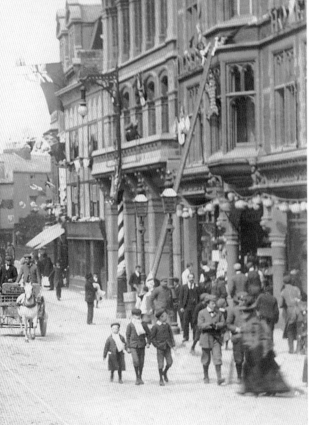

QUEEN STREET, DECORATED with patriotic flags during Queen Victoria's Diamond Jubilee in 1897 (left). Pedestrians spill out into the street to enjoy the decorations festooning shops like Badcock's, Jackson's and Prior's on the left. Beyond the Wilberforce Hotel on the right, the four-storey stone building formed the frontage for Hyde's Clothing Factory, a major employer of women and girls in Victorian Oxford.

THE FAÇADE OF the Wilberforce Hotel was retained during redevelopment in the 1980s and Hyde's frontage was shorn of most of its detail back in the 1960s. The Westgate Centre has terminated the view at the end of Queen Street since the early 1970s, occupying what locals knew as Macfisheries Corner at the corner of New Road and Castle Street.

ST ALDATE'S STREET
FROM CARFAX

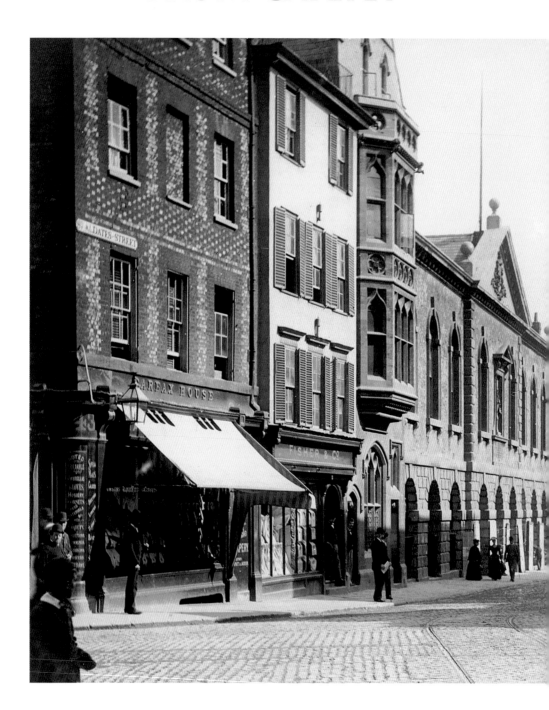

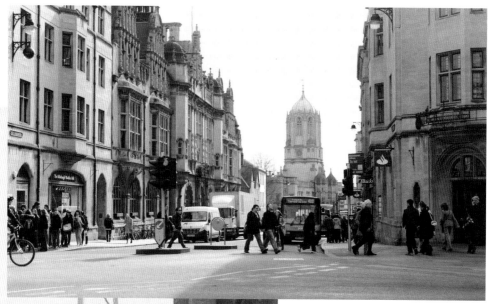

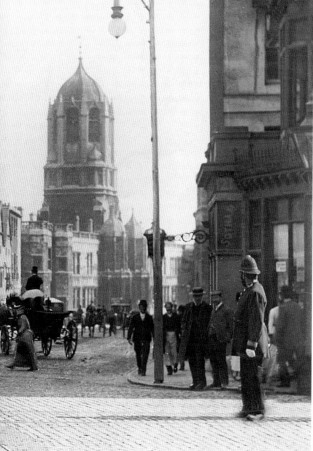

ST ALDATE'S FROM Carfax in 1893 (left), showing the town hall of 1751–2 and Tom Tower further down the street. A police constable is on duty at the entrance to Queen Street and a shop blind is down at Wyatt's the drapers to protect the stock from the afternoon sun. Electric street lighting had just been introduced at Carfax and the wooden lamp post was an embarrassing stop-gap measure because imported ornamental lamp standards had been slow to arrive.

TOM TOWER NOW forms the backdrop to a quite different scene. A new flamboyant town hall designed by Henry Hare was built between 1893 and 1895 and the southern corners of Carfax were set back and rebuilt in 1930–1. Traffic lights were installed at Carfax by the mid 1930s but the tradition of a 'Carfax Copper' stationed in the area continued for another forty years.

CHRIST CHURCH

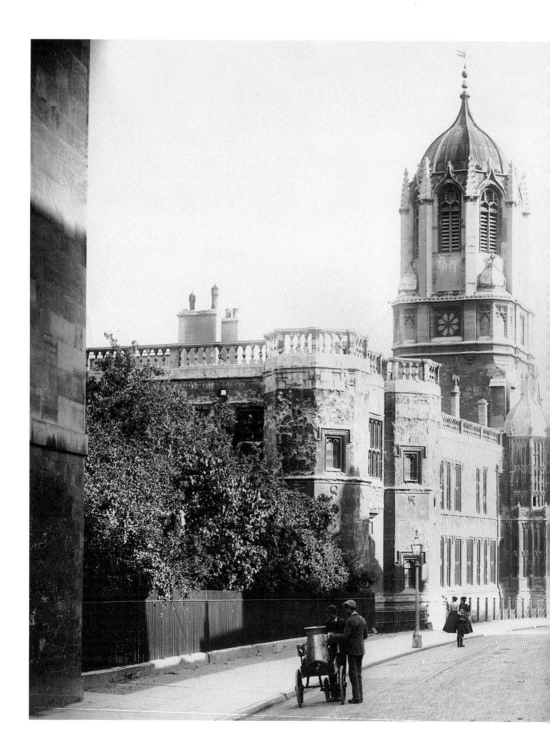

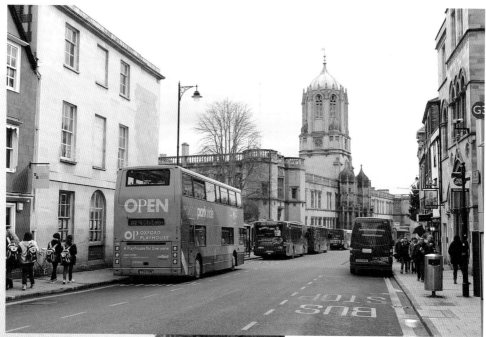

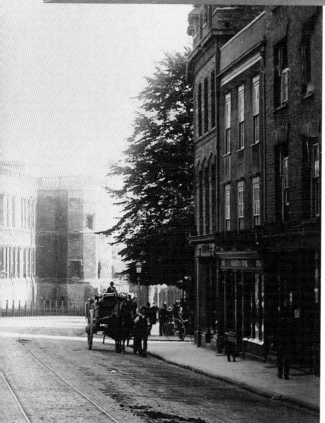

CHRIST CHURCH FROM St Aldate's in 1890 (left), with a milkman and his handcart in the foreground. The St Aldate's front of Christ Church was begun by Thomas Wolsey in the 1520s as part of his new Cardinal College but it was left unfinished at his downfall in 1529. Work resumed in the 1660s and it was only completed in 1681–2 when Tom Tower, designed by Sir Christopher Wren, was built above the entrance.

THE ST ALDATE'S front of Christ Church was largely refaced in the 1960s and the formerly soot-blackened Georgian house on the extreme left has also been cleaned and restored. Traffic levels in St Aldate's are much lower since the introduction of the Oxford Transport Strategy in 1999 but many bus services now stop here.

45

CHRIST CHURCH
TOM QUAD

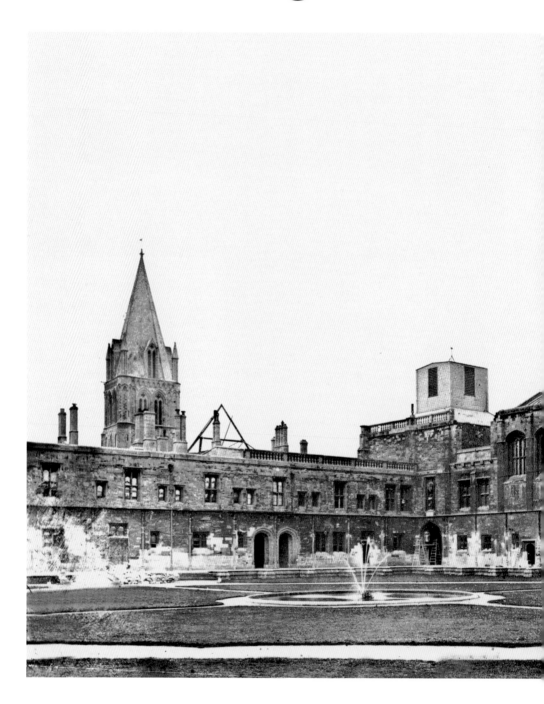

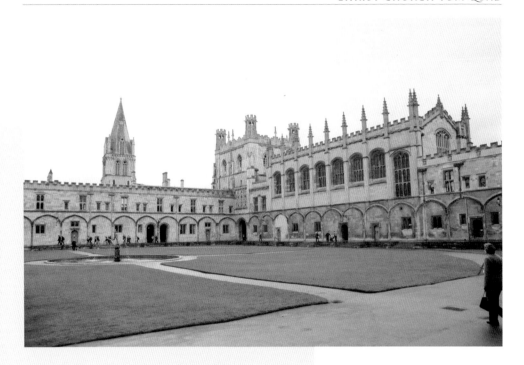

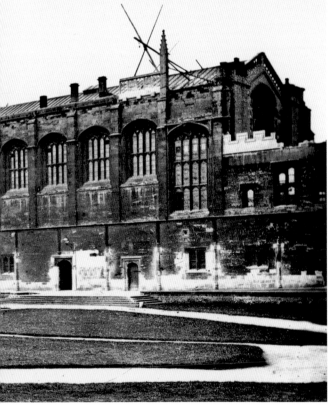

TOM QUAD AT Christ Church, c.1876 (left). This view shows the temporary belfry or 'tea chest' of 1872 which became a target for the wit of Charles Dodgson, then a tutor at Christ Church. Clean stonework is evidence of recent building work and the addition of battlements around the quad and pinnacles on the hall has just begun.

TOM QUAD'S BATTLEMENTS and pinnacles were completed in the later 1870s and the sumptuous Bell Tower, designed by Bodley & Garner, replaced the 'tea chest' in 1876–9. The same architects were also responsible for the vaulting around Tom Quad, suggesting the cloister which Wolsey had envisaged. The statue of Mercury in the centre of the quad was added in 1928.

CHRIST CHURCH
MEADOW BUILDINGS

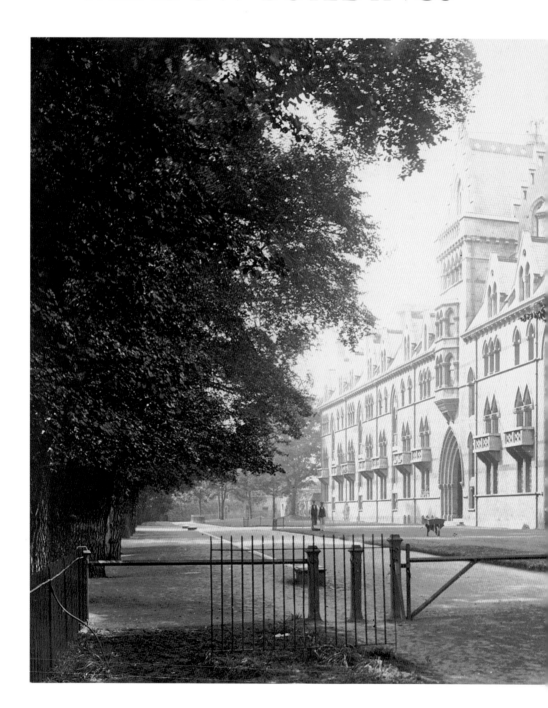

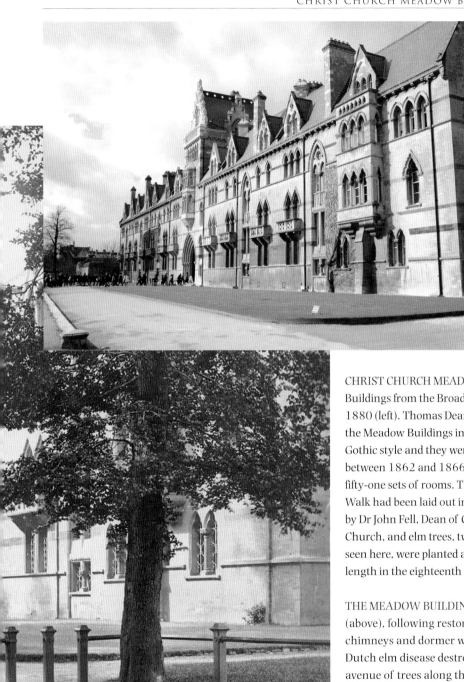

CHRIST CHURCH MEADOW
Buildings from the Broad Walk in
1880 (left). Thomas Deane designed
the Meadow Buildings in a Venetian
Gothic style and they were erected
between 1862 and 1866, providing
fifty-one sets of rooms. The Broad
Walk had been laid out in the 1660s
by Dr John Fell, Dean of Christ
Church, and elm trees, two of them
seen here, were planted along its
length in the eighteenth century.

THE MEADOW BUILDINGS today
(above), following restoration to
chimneys and dormer windows.
Dutch elm disease destroyed the
avenue of trees along the Broad
Walk in the 1970s and it now
has fewer trees, giving walkers
round Christ Church Meadow
more expansive views of Oxford's
historic buildings.

49

CORPUS CHRISTI COLLEGE

CORPUS CHRISTI COLLEGE and Merton College Chapel from Oriel Square, 1890. Richard Foxe, Bishop of Winchester, purchased the site of Corpus Christi College from Merton College in 1513 and the college buildings were occupied by 1517. The blackened north front seen here and the decayed portion of Oriel College to the left bear witness to the effects of air pollution on porous Headington stone.

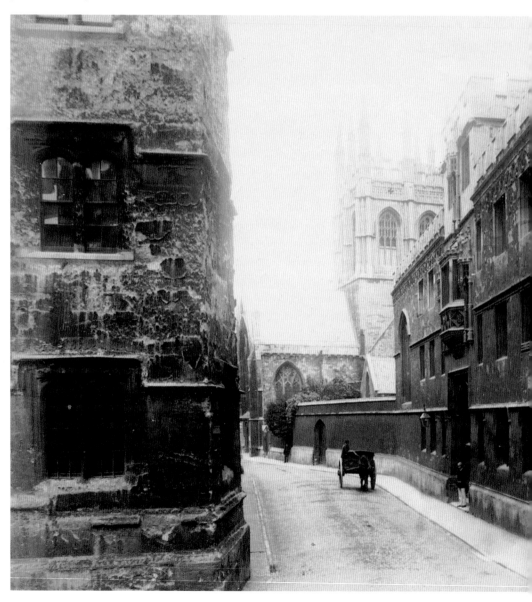

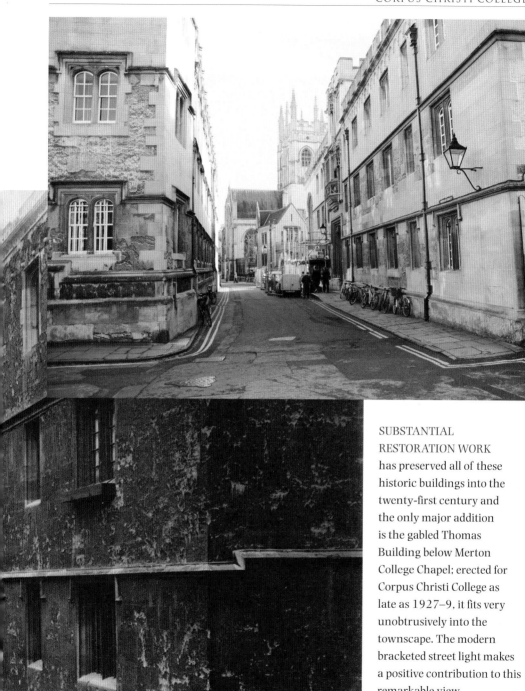

SUBSTANTIAL
RESTORATION WORK
has preserved all of these
historic buildings into the
twenty-first century and
the only major addition
is the gabled Thomas
Building below Merton
College Chapel; erected for
Corpus Christi College as
late as 1927–9, it fits very
unobtrusively into the
townscape. The modern
bracketed street light makes
a positive contribution to this
remarkable view.

CORPUS CHRISTI COLLEGE
FELLOWS' BUILDING

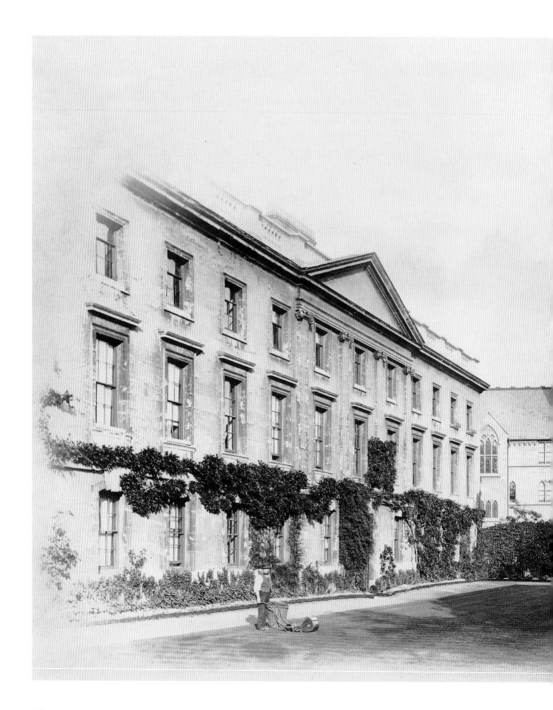

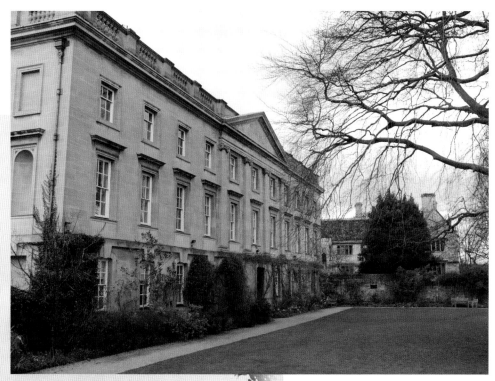

THE FELLOWS' BUILDING at Corpus Christi College, *c.*1865 (left). A college gardener poses with his lawnmower outside the Classical style building which was built between 1706 and 1712. William Butterfield's three-storey Grove Building, erected for Merton College in 1864, is visible in the background.

THE CRUMBLING SOUTH façade of the Fellows' Building was restored in the 1950s, making it a lovely backdrop to the sunny garden in the foreground. Spreading branches now mask the Grove Building that Merton dons found too prominent for their taste, having the top storey removed in 1930.

MERTON STREET

THE COBBLES OF Merton Street lead the eye towards Magdalen College tower in 1907 (right). The building on the left was part of T. G. Jackson's Examination Schools development of 1876–82. Beyond it, a group of three-storey houses dating from the seventeenth and eighteenth centuries contrast harmoniously with mature trees spilling over the rubble stone wall that marked the boundary of Merton College Fellows' Garden.

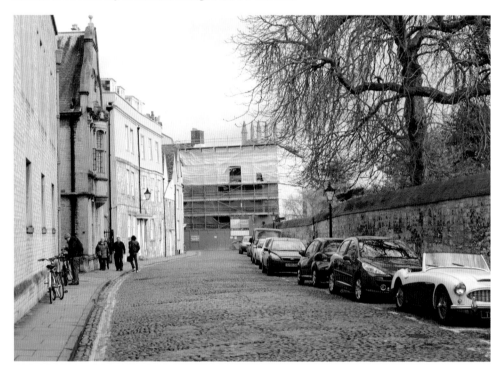

SCAFFOLDING HIDES THE Warden's Lodgings for Merton College which have blocked a fine view of Magdalen Tower since 1966. A few cars park beside the college boundary wall but Merton Street remains a delightful backwater. The traditional cobbled road surface was retained after a struggle in the 1960s, not least because it helped to slow motorists down.

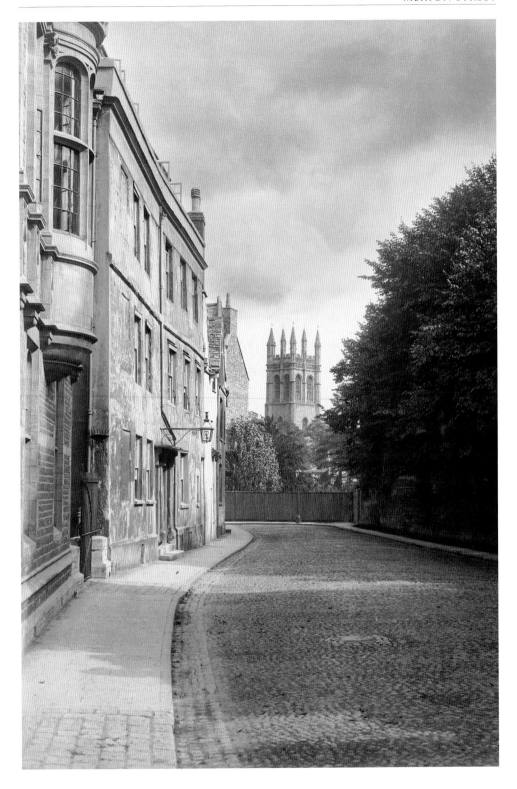

MAGDALEN BRIDGE

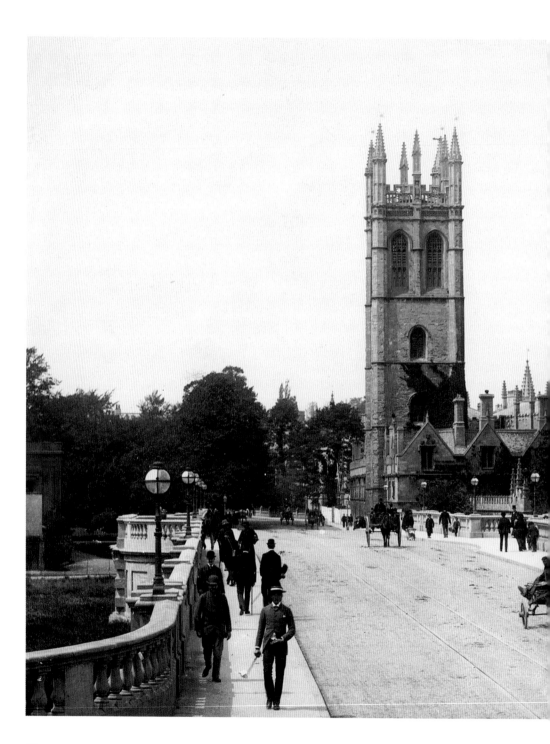

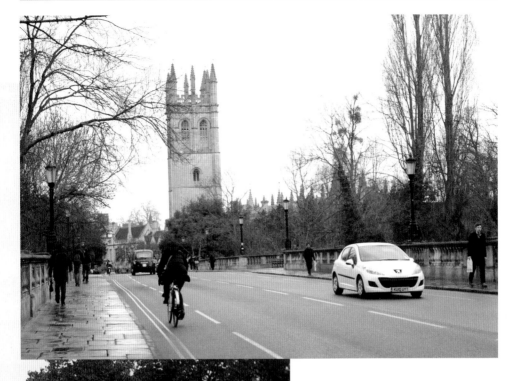

DONKEY-POWER AND horse-power on Magdalen Bridge, *c.*1885 (left). Magdalen Tower dominates the view as it has done since it was built for the recently-founded Magdalen College between 1492 and 1509. Magdalen Bridge had been rebuilt in the 1770s to designs by John Gwynn but growing traffic and horse-drawn trams led to sensitive widening in 1882–3.

MAGDALEN BRIDGE TODAY, equipped with cycle lanes and relieved of much of the motor traffic that came to dominate it. Magdalen Tower was refaced in the 1980s and is now an almost luminous feature at the end of the bridge. Magdalen Bridge itself was restored in the 1990s when balusters were renewed, parapets restored and stone paving was laid.

DREAMING SPIRES

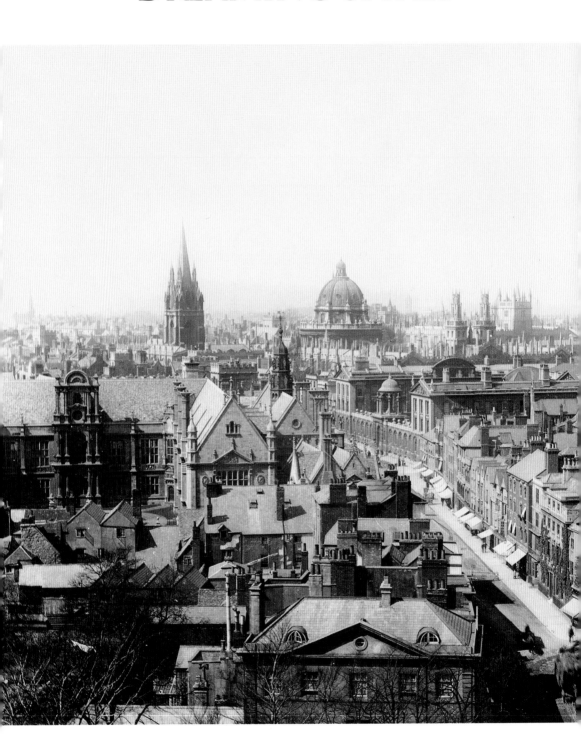

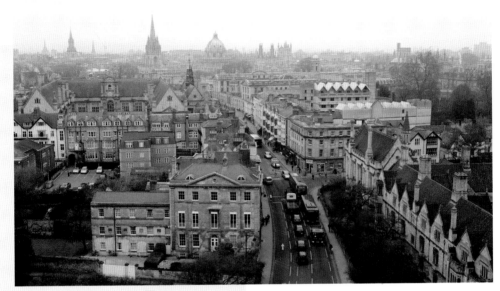

OXFORD FROM MAGDALEN Tower in about 1897 (left), an almost magical townscape that had evolved over many centuries. On the left, Thomas Graham Jackson's neo-Jacobean Examination Schools had been completed in 1883. Beyond the curve of High Street, the Radcliffe Camera (1737–49) and the fourteenth-century spire of St Mary the Virgin church are prominent features on the skyline. New College Tower (1396) can be seen away to the right behind the low thirteenth-century tower of St Peter in the East church.

HIGH STREET IS no longer quite so peaceful, particularly around the junction with Longwall Street in the foreground, but this special view of Oxford's towers and spires has scarcely changed. The Examination Schools are now partly obscured by the Eastgate Hotel of 1899–1900 and, to the north of High Street, St Edmund Hall added a residential block in 1968–70 which has a conspicuous six-gabled roof.

EASTGATE HOTEL

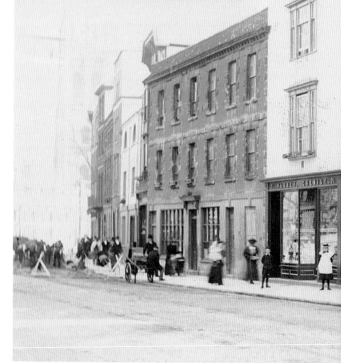

THE EASTGATE HOTEL at the corner of High Street and Merton Street, 1897 (right). The East Gate in Oxford's medieval town walls guarded the entrance to High Street at this point. The gate was finally cleared away in 1772 as part of a drive to modernise the city and widen its streets. The Eastgate Hotel building was probably erected soon afterwards and had become a pub, the Flying Horse, by 1840.

A NEW EASTGATE Hotel designed by E. P. Warren was built in 1899–1900 and extended much further down Merton Street than its predecessor. A cartouche on the High Street frontage at first-floor

level shows the former East Gate in the eighteenth century. Adjoining eighteenth- and nineteenth-century properties in High Street have been retained but the unusual brick façade of Nos 69–70 was rendered in 1935.

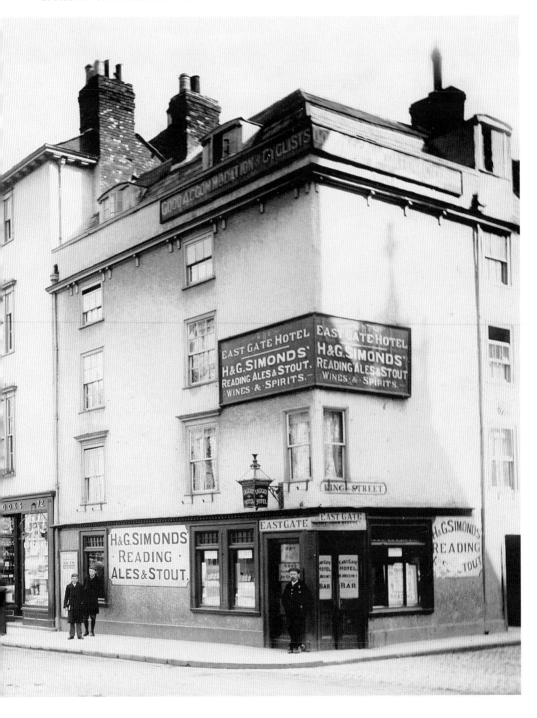

HIGH STREET

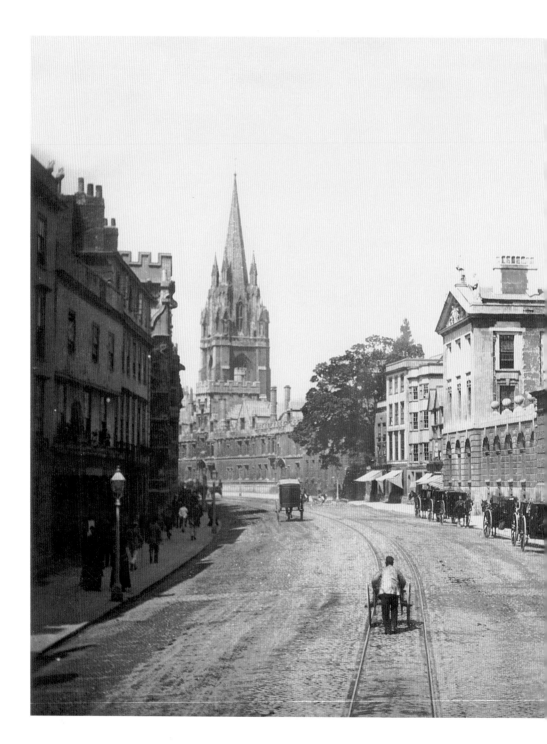

LOOKING WEST ALONG High Street from Queen's Lane in 1885 (below left). A man pushing a hand cart is taking advantage of the better road surface between the tram tracks in an otherwise peaceful street. Hansom cabs are waiting outside Queen's College, which dominates High Street at this point with its Classical front built between 1734 and 1760.

HIGH STREET WAS closed during the day to most traffic except buses in 1999, restoring for much of the time a peacefulness that had been lost during the 1920s. Recent road repairs have created the illusion of a central tramline, used here as a pedestrian refuge. Buses and cycles have taken over from hansom cabs outside a sparklingly restored Queen's College.

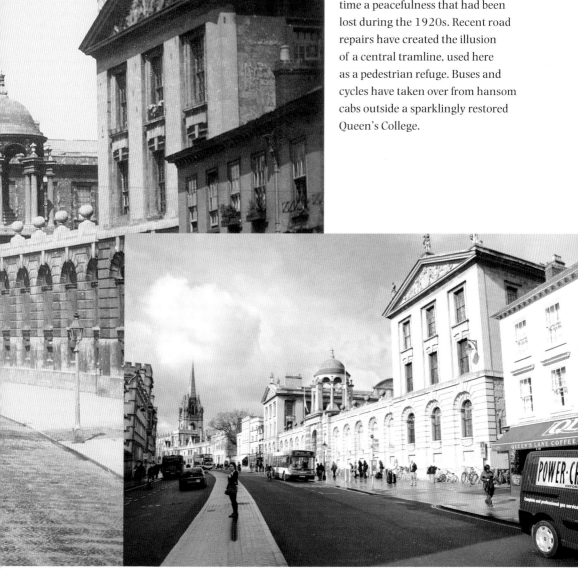

QUEEN'S COLLEGE

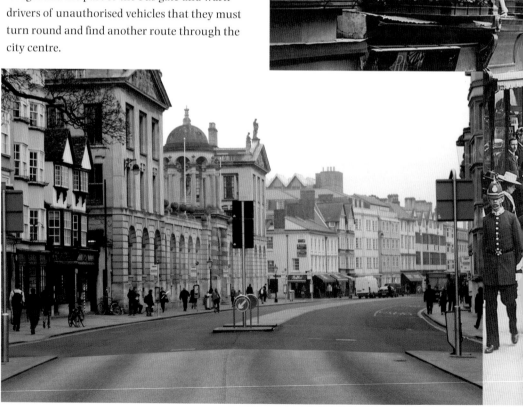

ENCAENIA PROCESSION OUTSIDE Queen's College, 1897 (right). Visitors and passers-by stop to watch the procession of people, led by university officials, who were on their way to the Sheldonian Theatre to receive honorary degrees. Traffic, including a horse-drawn tram, trundles on past regardless and some of the spectators seem more interested in the photographer on his stepladder.

THE ARCHITECTURAL FABRIC has changed remarkably little, apart from a glimpse of St Edmund Hall's 1960s development by Kenneth Stevens & Partners. The prominent signs in the foreground are part of the bus gate and warn drivers of unauthorised vehicles that they must turn round and find another route through the city centre.

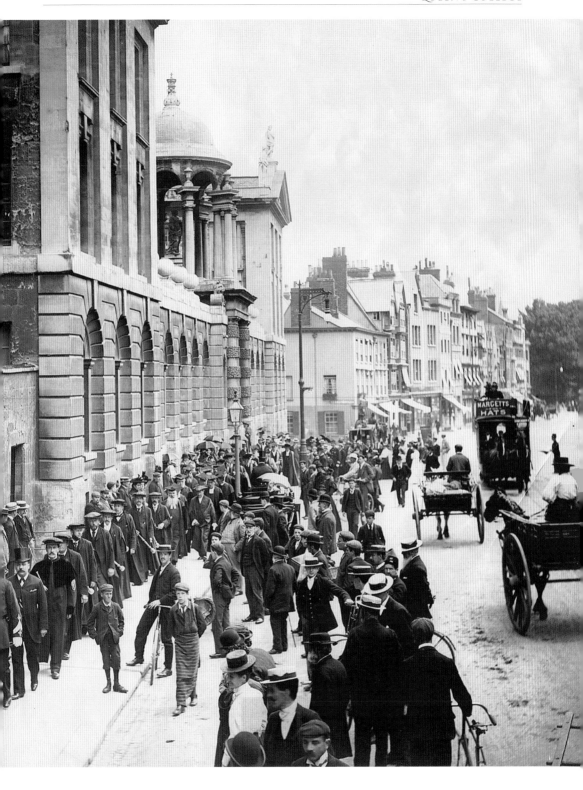

UNIVERSITY COLLEGE

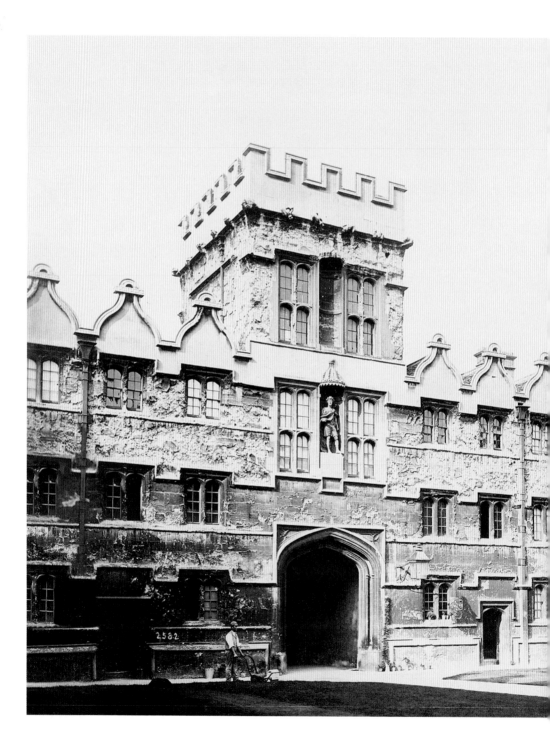

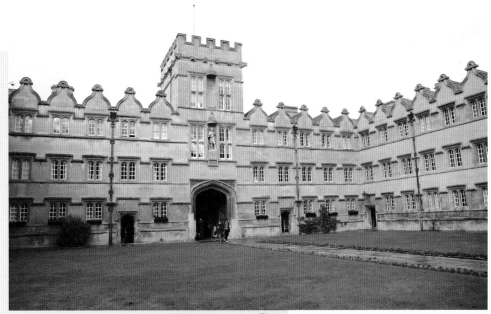

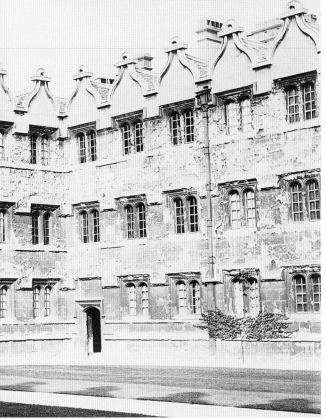

A COLLEGE GARDENER stands poised with his mower in the front quad of University College, *c.*1875 (left). The quad was built in stages between 1634 and 1677 and the statue of James II in a niche in the gate-tower was a final touch in 1687. The three-storey quad was built of local Headington stone which had clearly decayed by this time, requiring the replacement of battlements and parapets.

THE FRONT QUAD today (above), with all the stonework renewed and the condition of the buildings now matching that of the well-maintained lawns. Major restoration projects since the 1950s have transformed the look of many historic Oxford buildings.

ALL SOULS COLLEGE

HORSE-DRAWN TRAMS outside All Souls College in High Street, *c.*1890 (right). When horse trams were introduced into Oxford in 1881, people complained that they would ruin the High Street, and the tram company had to minimise disruptive noise outside the Examination Schools by laying wood blocks between the rails. This picture of single-decker trams in a historic setting shows that their impact was in fact quite negligible.

PUBLIC TRANSPORT IN the same place today (below) as the No. 400 bus for Thornhill Park and Ride car park passes through the bus gate outside All Souls College. A sycamore

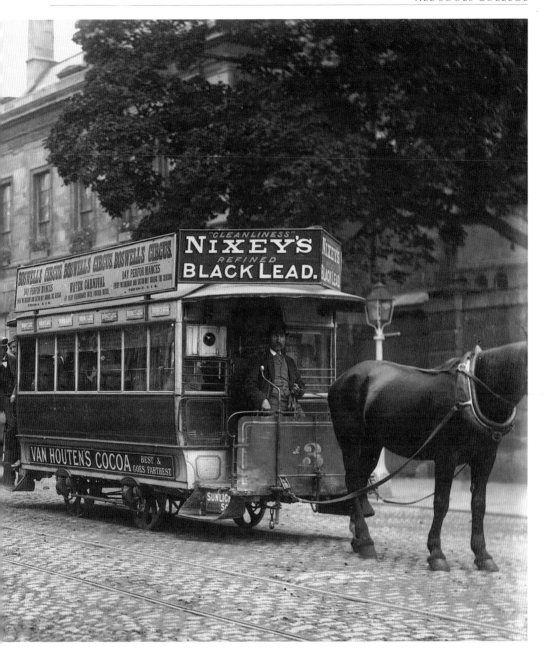

tree planted in the eighteenth century still overhangs the college wall at this point. Behind the bus, the Warden's Lodgings of 1704–6 and the adjoining Victorian Gothic range have both benefited from recent restoration.

BRASENOSE COLLEGE

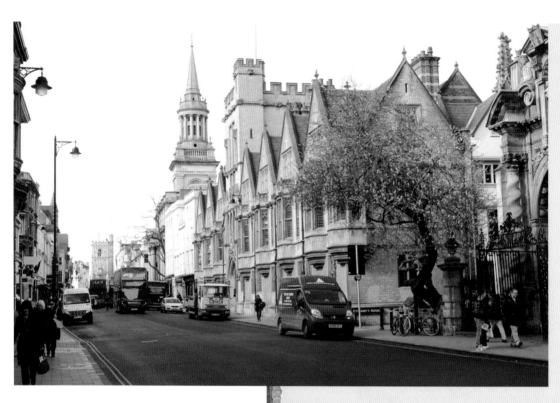

HIGH STREET, LOOKING west from
St Mary's Passage towards Carfax in
1885 (right). Standen's tailoring business
occupied No. 31 High Street on the corner
and the Principal of Brasenose College had
his lodgings in the eighteenth-century
house next door. The Oxford photographer
Henry Taunt began his long career at
Edward Bracher's photographer's studio at
No. 26 in 1856.

BRASENOSE COLLEGE HAD long nursed
the ambition to build on the High Street
frontage and this range designed by T. G.
Jackson achieved that objective between
1887 and 1911. Nos 24–31 High Street
were demolished, leaving just a few town

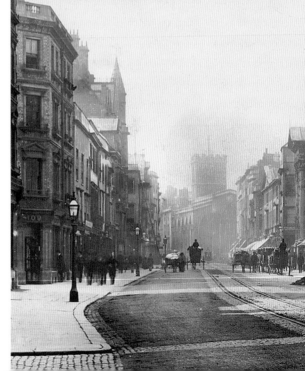

houses on this side of the road next to All Saints' church. Pink almond blossom is a springtime delight outside St Mary the Virgin church.

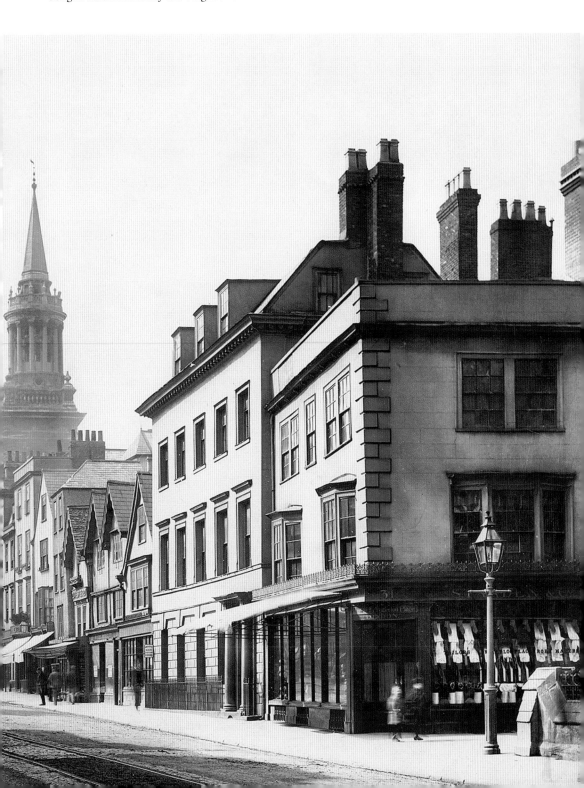

HIGH STREET
FROM TURL STREET

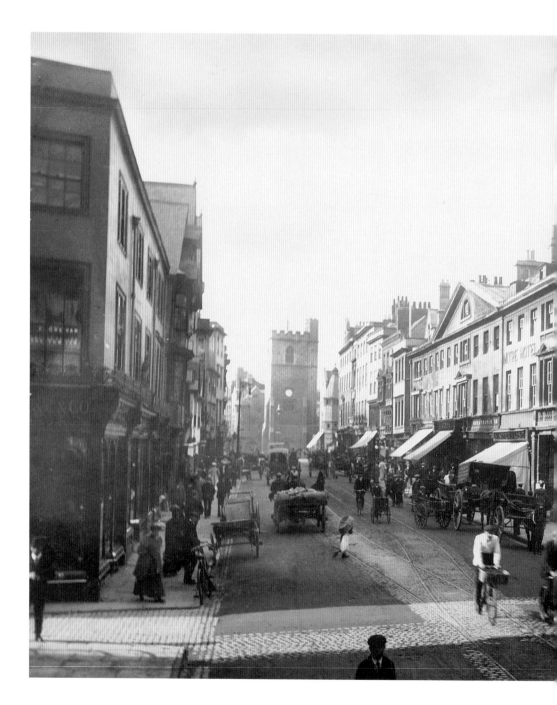

THE WESTERN END of High Street in 1907 (left), looking towards Carfax from Turl Street. Carfax Tower, rather than St Martin's church, now terminates the view, and cyclists, tramlines and a tall electric lamp standard have introduced a touch of modernity to the busy street scene. Prominent older buildings include the Mitre Inn, with an eighteenth-century and later façade on the corner of Turl Street and the Georgian frontage to the Covered Market, built in 1773.

THE VIEW IS little changed, even down to the lamp post on the corner of Turl Street. However, the differences here are only obvious to long-term residents who remember the Mitre as a hotel rather than as a restaurant and recall former High Street shops like Webber's, the International Stores and Sainsbury's.

TURL STREET

TURL STREET AND Lincoln College from the corner of Brasenose Lane, *c.*1870 (right). Lincoln College was founded in 1427 and the Turl Street frontage dates from the fifteenth century although it was considerably remodelled in the eighteenth century and then Gothicised in 1824. A gigantic horse chestnut tree billows across the cobbled street from the college stables and an early street nameplate, dating perhaps from the 1840s, announces Brasenose Lane.

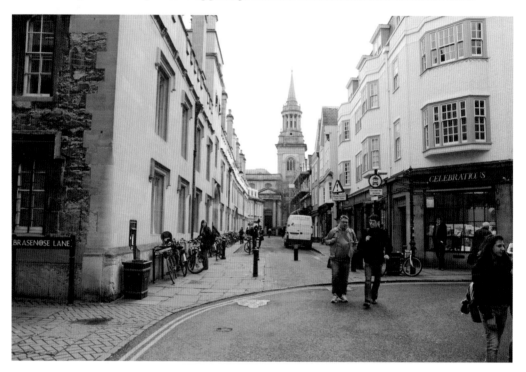

RECENT REFACING HAS altered the look of Lincoln College and Lincoln House, a neo-Georgian development, replaced the chestnut tree in 1938–9. The college built a small library at the end of the street in 1906 and then converted the redundant All Saints' church into a sumptuous library between 1971 and 1975. Bicycles now rule the roost in Turl Street and other traffic is restricted south of Market Street.

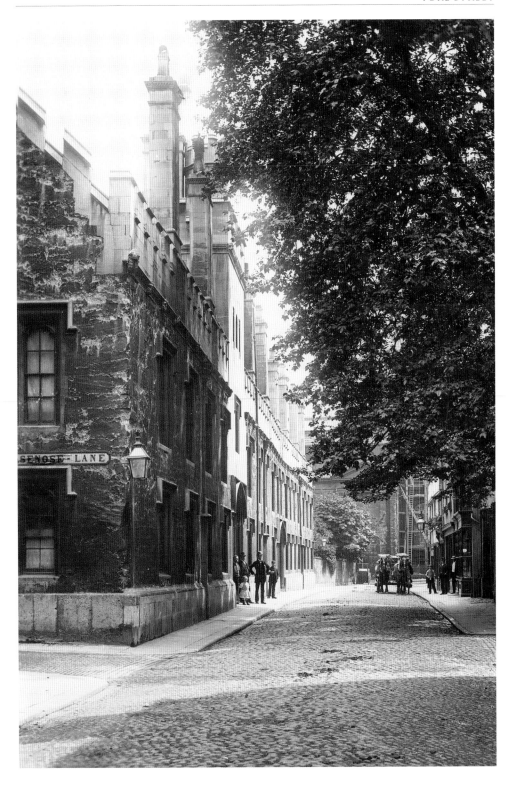

LINCOLN COLLEGE

THE FRONT QUAD of Lincoln College in 1914. The photograph was taken during the beating of the parish boundaries and shows boys involved in the ceremony grappling with the rather uncomfortable reward of heated pennies thrown from upper windows of the quad. The ivy-covered quad was built in the fifteenth century, with the later addition of sash windows and battlements.

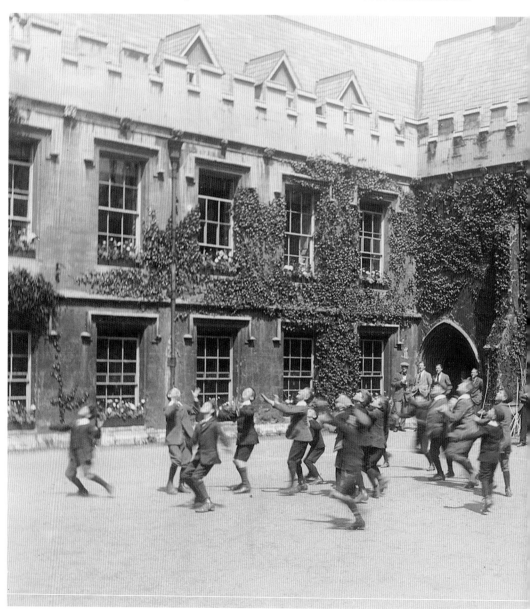

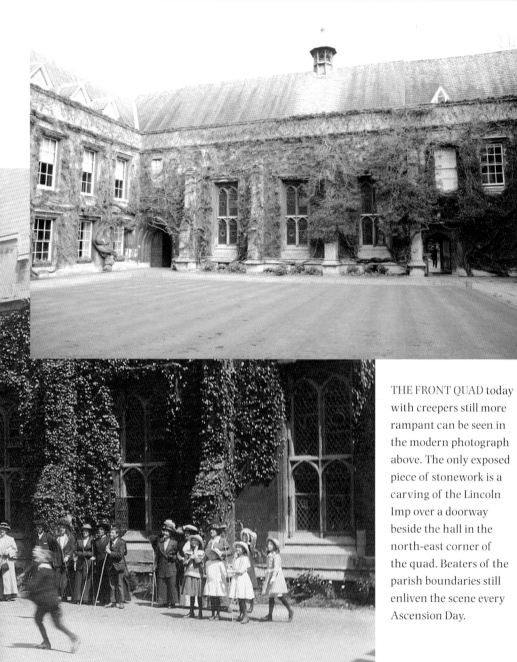

THE FRONT QUAD today
with creepers still more
rampant can be seen in
the modern photograph
above. The only exposed
piece of stonework is a
carving of the Lincoln
Imp over a doorway
beside the hall in the
north-east corner of
the quad. Beaters of the
parish boundaries still
enliven the scene every
Ascension Day.

RADCLIFFE CAMERA

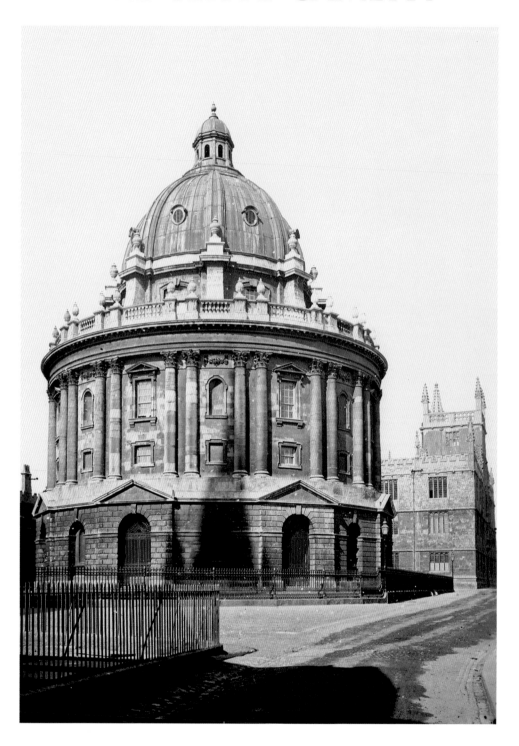

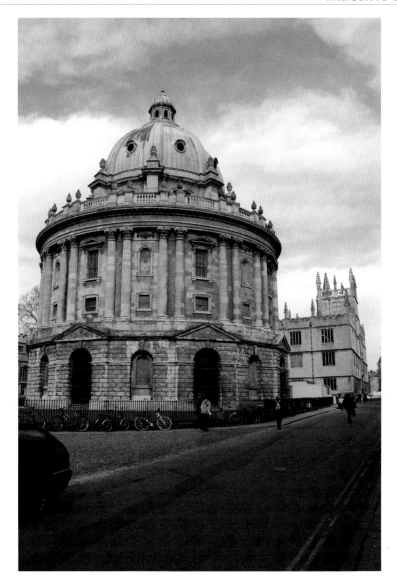

THE RADCLIFFE CAMERA from the south-east in 1865 (left). This striking circular library was built with money left to the university by John Radcliffe (1652–1714), fellow of Lincoln College and court physician to William III and Queen Anne. It took many years to acquire the site and select an architect, and the Radcliffe Camera, designed by James Gibbs, was not completed until 1749.

BOTH THE RADCLIFFE Camera and the Bodleian Library further along Catte Street now sparkle in the sunshine. Iron railings around the Camera, installed in 1836 to deter undesirable folk from sheltering in the once open loggia under the building, were removed as unfashionable in 1936. They returned in the 1980s to stop people sprawling noisily outside this most delightful of libraries and were quickly adopted for cycle parking.

RADCLIFFE SQUARE

BRASENOSE COLLEGE AND Radcliffe Square in 1875. The sixteenth-century front of Brasenose College is visible beyond the spreading branches of a fine horse chestnut tree, Heber's Tree, in Exeter College Fellows' Garden. The tree was so-called because it shaded the Brasenose College rooms of Reginald Heber (1783–1826), later bishop of Calcutta. Before railings were erected around the Camera, a group of drunken dons from Brasenose is said to have spent a night going round and round the building trying to find their way back.

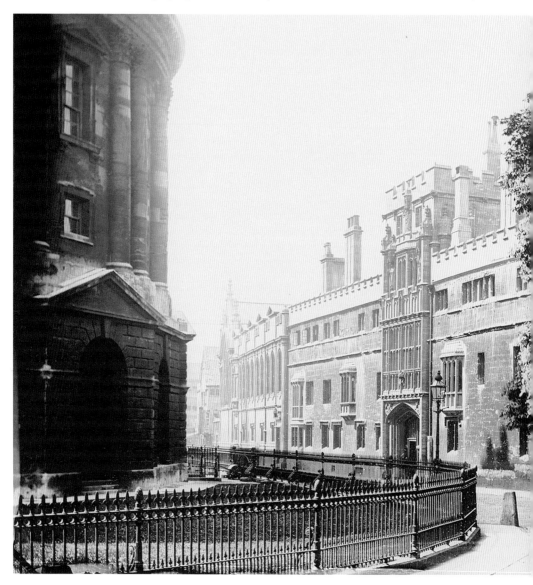

HEBER'S TREE HAS gone
and Brasenose College, with
newly-restored battlements, is
much more evident. The entrance
to Brasenose Lane is also revealed
beside the high wall to Exeter
College Fellows' Garden. The
cobbled and paved street surface of
Radcliffe Square, re-laid in 2005,
complements the architectural
delights of this splendid townscape.

HERTFORD
COLLEGE
BRIDGE OF
SIGHS

NEW COLLEGE LANE from Catte Street in 1880 (right). The New College bell tower in the background was erected in 1396 and was the first documented building in Oxford to be built of limestone from the local Headington quarries. Hertford College, founded in 1874, had recently taken over the buildings of Magdalen Hall to the right of New College Lane which were erected in 1820–2.

HERTFORD COLLEGE'S 'BRIDGE of Sighs', designed by T. G. Jackson and built in 1913–14, now hides the

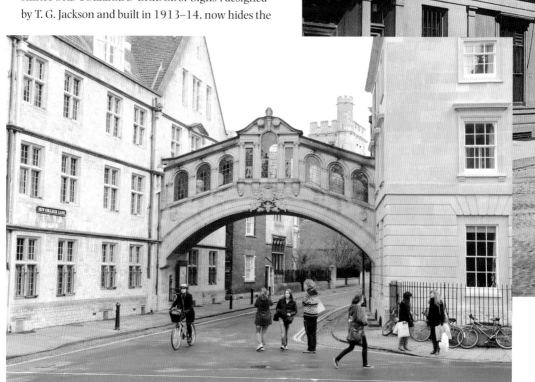

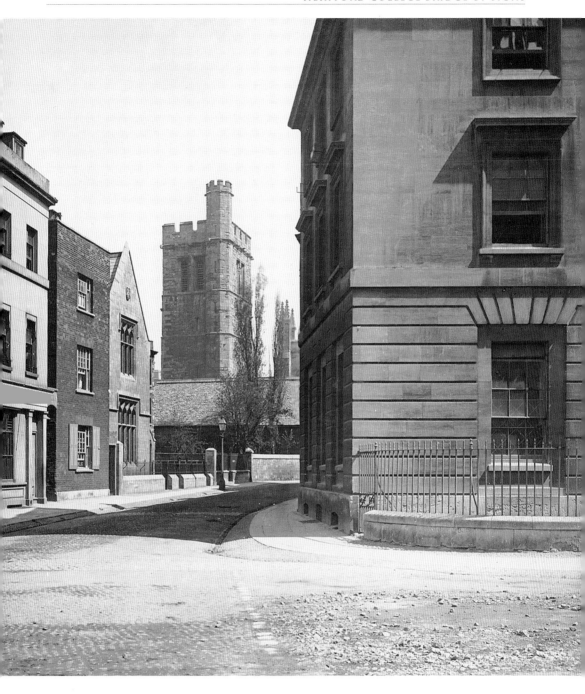

New College bell tower. One of Oxford's best-known landmarks, the bridge links old quad and the Jackson-designed north quad, which was built between 1900 and 1931. The tunnel which he originally envisaged would not have been so photogenic!

HERTFORD COLLEGE AND CLARENDON BUILDING

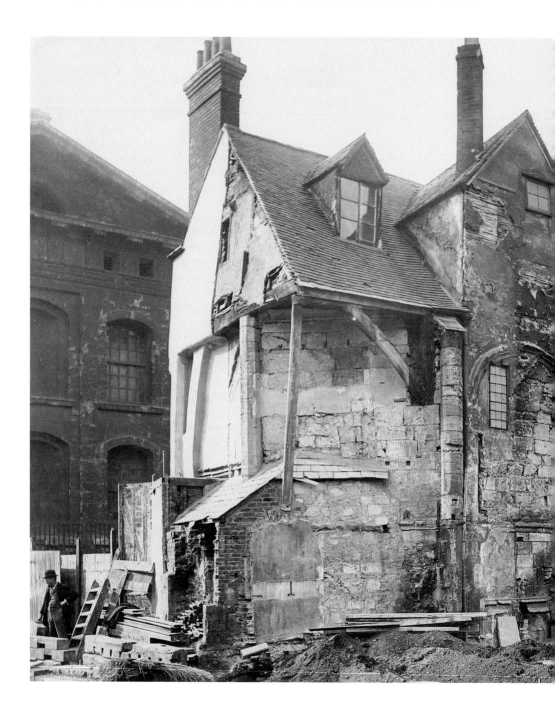

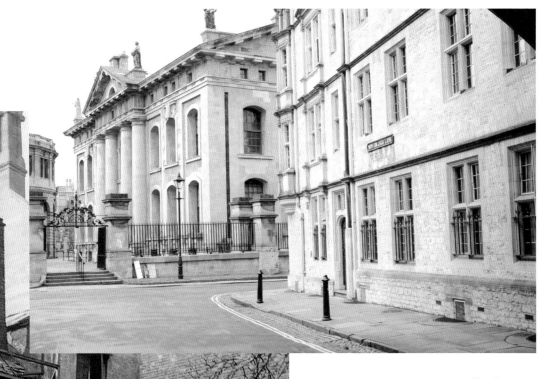

DEMOLITION FOR HERTFORD College's north quad exposes the remains of the Chapel of Our Lady in Catte Street in 1902 (left). The octagonal chapel had been built in 1521 next to the Smith Gate in Oxford's city wall. The building was later converted to secular use and was sometimes incorrectly described as Oxford's oldest house. Aware of the chapel's true significance, T.G. Jackson, the college architect, decided to incorporate it in the new quad.

THE NEW COLLEGE Lane frontage of Jackson's north quad now obscures the chapel, which was largely rebuilt to form the Hertford College junior common room. On the opposite side of Catte Street, the Clarendon Building was designed by Nicholas Hawksmoor and built for the Oxford University Press in 1711–13.

NEW COLLEGE LANE

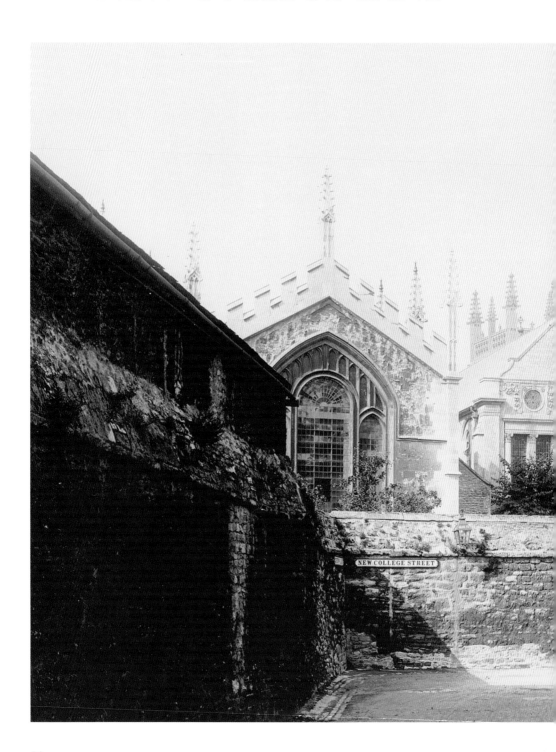

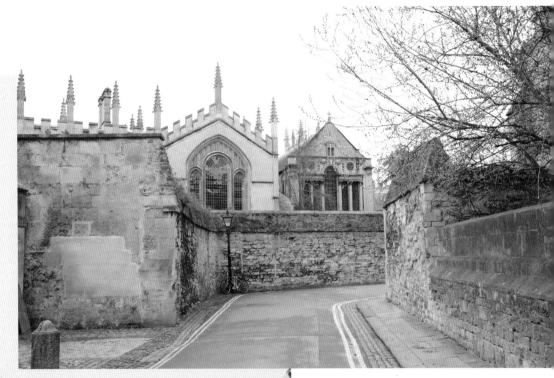

A QUIET CORNER of New College Lane in 1908 (left). The view shows the property of four colleges, including Queen's College stabling on the left and the New College boundary wall on the right. Beyond an ancient rubble stone wall, the Codrington Library of All Souls College, completed in 1720, stands to the left of the newly built Hertford College Chapel, designed by T. G. Jackson.

RESTORED STONEWORK AND yellow lines are perhaps the most obvious changes in this hugely atmospheric part of Oxford. New Provost's Lodgings for Queen's College in 1958–9 led to the loss of some of the wall on the left and, after the removal of iron railings, New College added to the height of their boundary wall to deter intruders.

HOLYWELL STREET

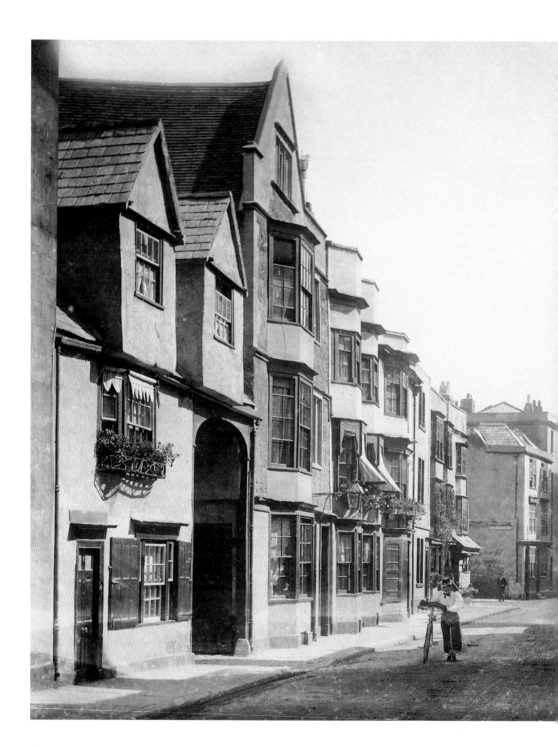

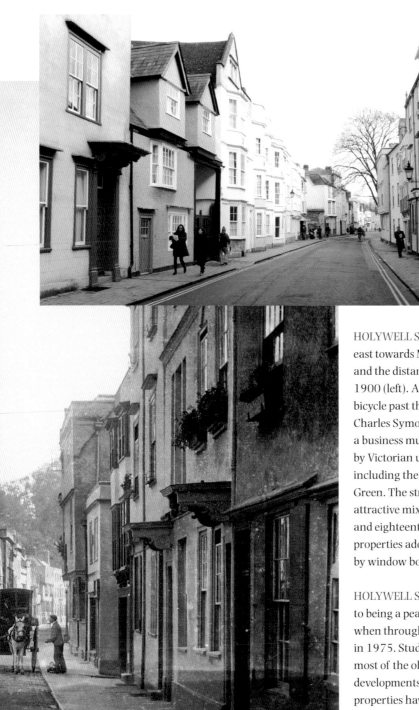

HOLYWELL STREET, LOOKING east towards Mansfield Road and the distant Magdalen Grove, 1900 (left). A woman pushes her bicycle past the arched gateway to Charles Symonds' livery stables, a business much frequented by Victorian undergraduates, including the fictional Verdant Green. The street was an attractive mixture of seventeenth- and eighteenth-century properties adorned here and there by window boxes and sun blinds.

HOLYWELL STREET REVERTED to being a peaceful backwater when through traffic was banned in 1975. Students now occupy most of the old houses and college developments behind these properties have left their frontages almost unchanged. The sycamore tree billowing into the street adds character to the scene.

TRINITY COTTAGES
AND BROAD STREET

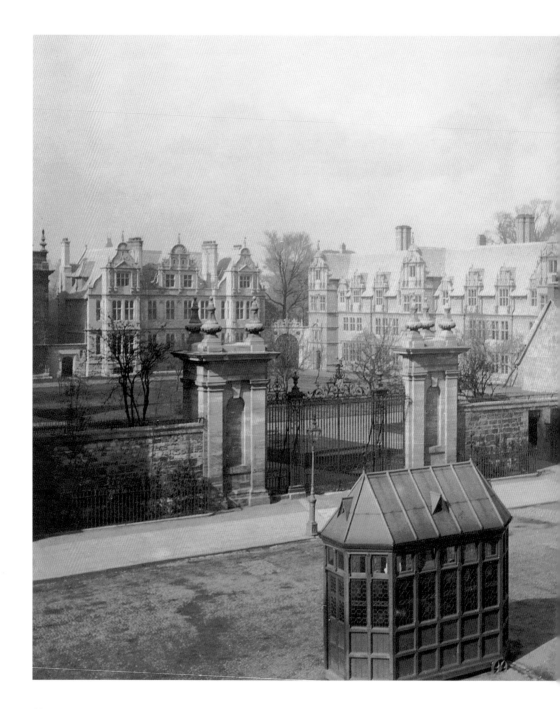

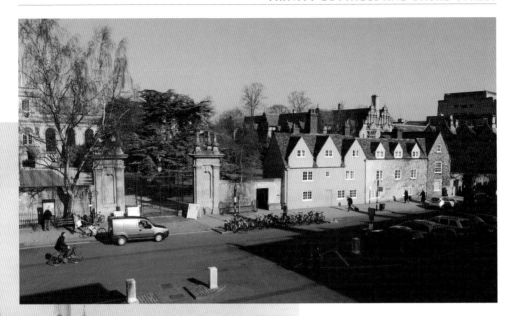

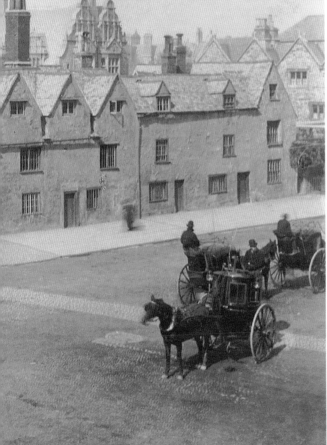

TRINITY COLLEGE FROM an upper window of Nos 9 and 10 Broad Street in the late 1880s (left). Behind the ornate seventeenth-century gate and contemporary cottages, Trinity College was experiencing a period of expansion with the building of the north and east ranges of front quad to designs by T. G. Jackson. Broad Street became a cabstand in the later nineteenth century and well-wishers subscribed to the wooden shelter in 1885, providing cabbies with a refuge from the weather between fares.

THE CENTRE OF Broad Street has been a car park since 1928 but there are plans to transform it into a grand urban space at the heart of the university. The façades of Trinity Cottages were retained in the 1960s when the buildings were adapted for college use. The New Bodleian Library away to the right represented more drastic change when it was built between 1938 and 1940.

BALLIOL COLLEGE NEW HALL

DONS OUTSIDE THE New Hall at Balliol College in 1886 (right). Balliol was growing both in size and reputation during the Victorian era and the New Hall, designed by Alfred Waterhouse, was built in 1876–7 to replace the small fifteenth-century hall in the front quad. Staircase XXII, partly visible to the left, had been built at the same time to provide extra accommodation.

ONE MATURE TREE largely hides Waterhouse's Hall and another

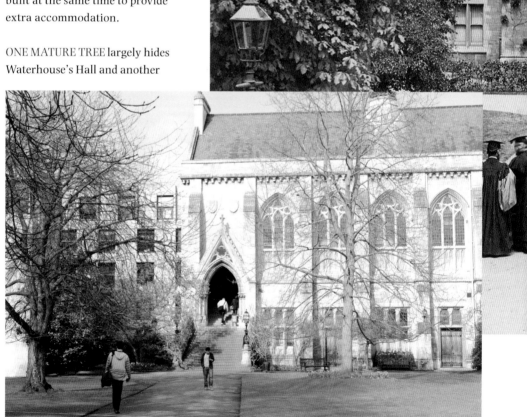

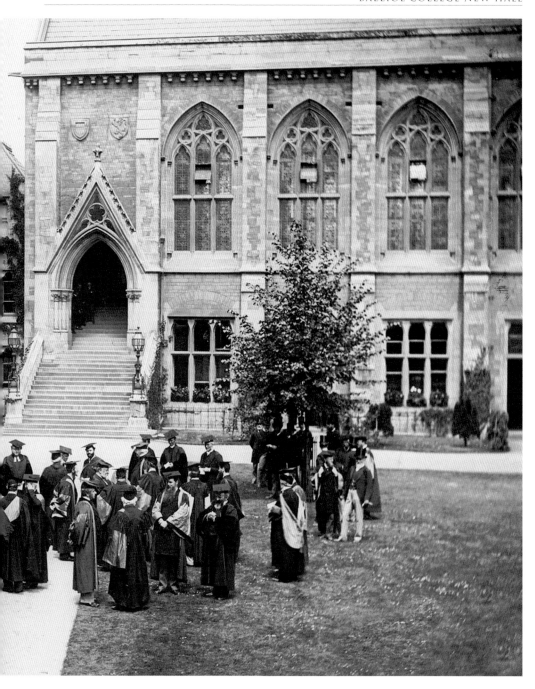

obscures the Bulkeley-Johnson Building to its left. The latter was designed by Geoffrey Beard of Oxford Architects Partnership and built on the site of Staircase XXII in 1968.

BROAD STREET

BROAD STREET IN 1904, looking east past Balliol College. The Master's Lodgings on the left and the Balliol front beyond were designed by Alfred Waterhouse and built in 1867, replacing

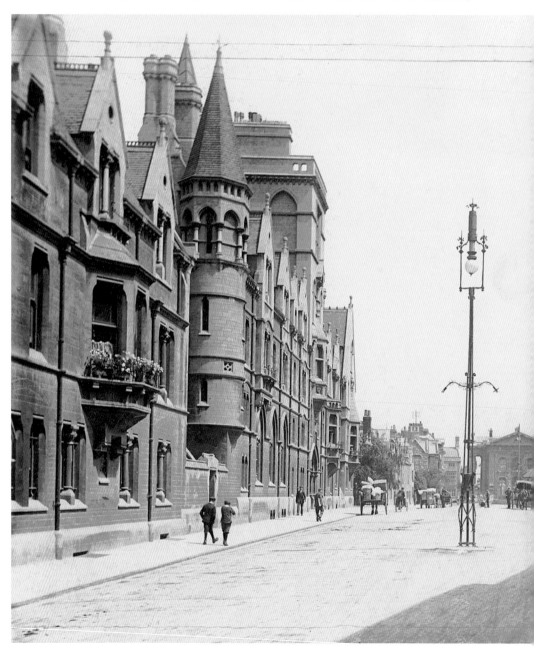

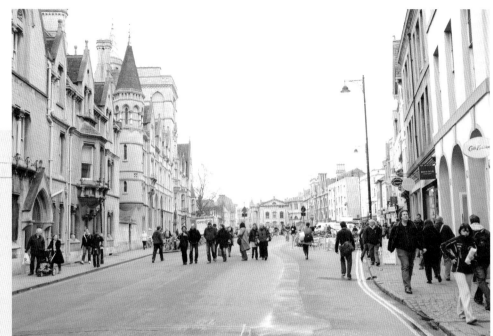

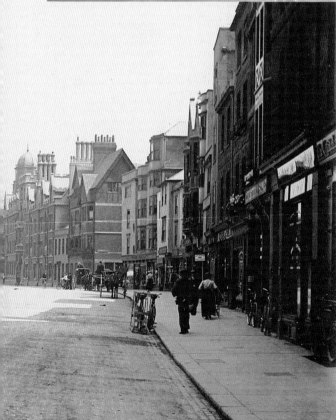

Georgian buildings. Exeter College, beyond Turl Street, had also changed the face of Broad Street with a new range built between 1833 and 1856. The ornate but poorly-sited street lamp had recently introduced electric light to the street.

TALL LAMP STANDARDS in a neo-Victorian style now light Broad Street. Twentieth-century schemes to redevelop old properties on the right fortunately came to nothing and the major alteration to the street scene is the Thomas Wood Building of Exeter College, a plain ashlar stone structure on the far corner of Turl Street built in 1964.

Other titles published by The History Press

Oxfordshire Customs, Sports & Traditions

MARILYN YURDAN

The people of Oxfordshire certainly know how to enjoy themselves, and take part in many varied and remarkable customs, sports and traditions that are held annually around the county. Some of these, like the May Morning and Beating the Bounds, go back for centuries but have been altered and adapted over the years. Others are relatively recent revivals, such as the agricultural show at Thame, which is Victorian in origin. Each one featured is a unique celebration of Oxfordshire's heritage.

978 0 7524 5743 7

Working Oxfordshire: From Airmen to Wheelwrights

MARILYN YURDAN

Featured in this book are carvers and barrel makers, university employees and leather-workers, hop-pickers and bee-keepers, brewers and marmalade makers, railwaymen and bus drivers, thatchers and blacksmiths, and, of course, shops galore. With 200 superb photographs, this book will appeal to everyone with an interest in the history of the county, and also awaken memories of a bygone time for those who worked, shopped or simply remember these Oxfordshire firms, trades and businesses.

978 0 7524 5585 3

Oxford Student Pranks

RICHARD O. SMITH

This fascinating volume recalls some of the greatest stunts and practical jokes in the university's history, including those by Oscar Wilde, Percy Shelley, Richard Burton and Roger Bacon. Ranging from the stunt that gave Folly Bridge its name to the long-running rivalry between Town and Gown and the exploits of the infamous Bullington Club, this enthralling work will amaze and entertain in equal measure – and may well prove a source of inspiration for current students wishing to enliven their undergraduate days.

978 0 7524 5650 8

An Oxford Childhood

PHYL SURMAN

A personal reminiscence of growing up in Cowley, Oxford in the 1920s. The author's detailed memories describe every aspect of life in the years following the First World War. The clothes she wore, the furnishings of her parents' house and the food they ate are all remembered in detail. She describes schooldays, shopping, street games and the arrival of Welsh miners who walked to Cowley from Wales to find work. This charming book is illustrated with drawings by Max Surman and some delightful contemporary photographs.

978 0 7524 5063 6

Visit our website and discover thousands of other History Press books.

www.thehistorypress.co.uk